DISCARD

Woodbourne Library
Washington-Centerville Public Library
Centerville, Ohio

IMAGES
of America

DAYTON

D1193193

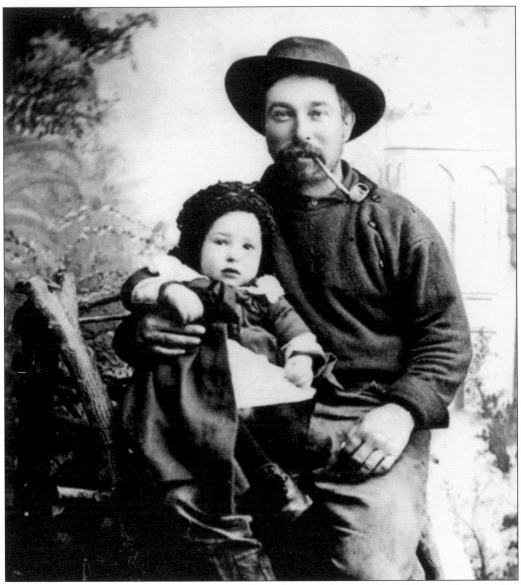

Andrew Walmsley and his son Zenas pose for a photograph around 1885. For 155 years, five generations of Walmsleys have been respected, prominent Dayton citizens. Andrew's father, James, moved here in 1859. Andrew, Zenas, his son Ray, and Ray's wife, May, also raised their families in Dayton. Zenas served as Dayton's justice of the peace. Ray, 87, considered Dayton's patriarch, passed on in 2014. May and her daughter Geri carry on the Walmsley ancestry in Dayton. (Historical Society of Dayton Valley.)

ON THE COVER: Fred Kelly (left) and Hugh Davis provide perspective of the size of a clamshell used to dredge the Carson River to recover the tons of gold, silver, and mercury that were lost upstream in milling operations during the Comstock Lode bonanza days. In 1878, speculator J.H. Rae Sr. formed the Carson River Placer Mining & Dredging Company and spent $120,000 to erect Nevada's first dredge. By 1894, his experiment had failed. He upgraded the system, hiring Sacramento River mine-dredging experts to remedy his problems. (Nevada Historical Society.)

IMAGES
of America

DAYTON

Laura Tennant and Jack Folmar

ARCADIA
PUBLISHING

Copyright © 2015 by Laura Tennant and Jack Folmar
ISBN 978-1-4671-3326-5

Published by Arcadia Publishing
Charleston, South Carolina

Printed in the United States of America

Library of Congress Control Number: 2015930791

For all general information, please contact Arcadia Publishing:
Telephone 843-853-2070
Fax 843-853-0044
E-mail sales@arcadiapublishing.com
For customer service and orders:
Toll-Free 1-888-313-2665

Visit us on the Internet at www.arcadiapublishing.com

Dedicated to Delphine "Del" Minor and Winston "Stony" Tennant for their love of the Dayton historical culture and their admiration for the pioneers who toiled here.

CONTENTS

ACKNOWLEDGMENTS

This photographic journey through Dayton's history has been a labor of love. The book would not have become a reality without the support of the residents whose ancestors settled here and the dedicated volunteer members of the Historical Society of Dayton Valley, who continue to keep the town's past alive.

My heartfelt thanks go to my coauthor and friend Jack Folmar, the Historical Society of Dayton Valley photographer who gave his all to produce 700 photographs to choose from for this project, and to his wife, Alice, who put up with us.

Also, I cannot express in words how much I appreciate the editing expertise, patience, and encouragement shown by my friends David Moore, retired *Nevada Magazine* editor, and his wife, Barbara Peck, Dayton historian and former schoolteacher.

Also, I offer a thousand thanks to my friend and colleague Dr. Linda Clements, a purist when it comes to history—especially Dayton's. Linda is also a professional editor who burns the midnight oil regularly.

I will be forever grateful to my sister Gloria Manning, who tackled the layout plan, did Internet research, and solved numerous issues daily; and to my husband, Stony, who provided constant support during the last year.

All of us spent untold hours to produce the most historically accurate documentation of Dayton's history to the best of our abilities.

Special thanks go to the Dayton families who donated pictures and text from their archival collections, including those of Zenas and Ray Walmsley, Will Scott, and Herman Davis. Unless indicated otherwise, photographs are courtesy of the Historical Society of Dayton Valley. Other sources include the Nevada Historical Society (NHS), Nevada State Museum (NSM), and the Comstock Historic District (CHD). And finally, without the professional and patient guidance of title manager Ginny Rasmussen, production editor Tim Sumerel, and the rest of the congenial Arcadia Publishing staff, this Dayton book would never have been published.

INTRODUCTION

Dayton's 162-year-old story holds more significance in Nevada history than most people realize. Some 93 years have passed since the Nevada Historical Society published Fanny Hazlett's "Historical Sketch and Reminiscences of Dayton, Nevada" in its book *Historical Society Papers, 1921–1922*, and Dayton's contribution to the state's earliest development has nearly been forgotten. The town's name and history have even been omitted from some textbooks on Nevada history. If it were not for the immigrants who saw this area in the 1850s and 1860s and kept diaries, as well as the early Dayton families whose descendants have maintained archives of photographs and historical stories, the town's rightful place in American history would have been lost.

Dayton lies in a fertile valley along the Carson River, 12 miles east of Carson City, the state capital. Around 10,000 years ago, the waters of the prehistoric Lahonian Lake lapped at the shores of Dayton Valley. Artifacts left in the lowlands and surrounding mountains indicate Native Americans inhabited this area thousands of years before Euro-Americans settled here in the 1850s.

Early white settlers who traveled in pack trains from California to Salt Lake City followed established Indian trails through what is now Dayton. After trail guide Abner Blackburn first found gold in Nevada, at the mouth of Gold Canyon in 1849, the word spread and miners began settling here.

In 1850, Congress created Utah Territory, which included the area called the Carson Valley. The valley ranged from the Sierra Nevada at Genoa to east of Dayton. When the Gold Rush began in California in 1848, Dayton's Indian trails quickly became roadways for pedestrians, wagons, horses, cattle, and sheep. Dayton's history had become exciting.

In 1851, Washington Loomis and Nathaniel Haskill opened a tent trading post near the mouth of Gold Canyon. For some reason, they challenged territorial sheriff William Byrnes to a shooting contest and then, at the meeting site, one of them tried to shoot him. Angered by these actions, prospectors formed the first "miners court" in Nevada. Afraid of being lynched, Loomis and Haskill fled to California.

By 1852, Andrew Spoffard Hall of Fort Wayne, Indiana, owned the trading post and Hall's Station became the only stop on the trail west for 40 miles. Thousands of immigrants passed through this valley. A few ladies are memorable because they kept diaries about life on the trail.

Lucena Puffer Parsons, 26, on her honeymoon, kept a daily diary when she and her husband, George, left Missouri bound for California in 1850. The Parsons' wagon company reached Gold Canyon on May 25, 1851. The travelers spent 13 days camping with the 200 placer miners at work in the canyon, and Lucena wrote in her diary every day. She even notes that John Reed and his party stopped there to prospect on their way to build Mormon Station. Lucena did not know that she had recorded Dayton's earliest written history.

Immigrants Lucy and William Cooke and their baby, Sissy, arrived at Hall's Station in May 1853 after months on the trail. In a letter to her sister, written from the area of today's Dayton, Lucy says her husband hired on as a miner for $50 a month with room and board at Hall's trading post and tavern. "Everyone stops here and pack trains from Sacramento arrive frequently," Lucy

writes, adding that "this is a great rendezvous for gamblers, and the miners gamble with playing cards all night."

Also in 1853, Laura Ellis Dettenrider and her husband, George, arrived in Dayton via wagon. Laura kept a journal and recorded a treasure trove of early Nevada history happening around Dayton, including the first marriage and first divorce. One of Laura's tidbits of news is that 213 wagons, 360 horses and mules, and 7,150 sheep passed across this settlement's immigrant trails in July 1854. The Parsons had built a log cabin on the river and developed a farm, and Laura documented details of the unprecedented migration west as it happened here.

Meanwhile, Gold Canyon placer miners continued working the bed of Gold Canyon Creek in the winter, when there was water in the creek. They needed a water source for summer gold mining. So, in 1857, Edward Rose and his associates hired 50 or more Chinese men in San Francisco and brought them to Dayton to dig a four-mile-long water ditch from the Carson River west of town to the placer miners in the canyon. When the ditch was finished in 1858, some of the Chinese workers prospected for gold and built shelters along the Carson River in what is today Dayton; this became Nevada's first Chinatown.

In 1859, times were destined to change in this end of Utah Territory. Working their way up Gold Canyon, the prospectors hit pay dirt above the modern site of Virginia City and found the world's richest vein of silver, still referred to as the Big Bonanza and Comstock Lode. Thousands of miners swarmed to Utah Territory. Nearly every able-bodied man in the lower canyon at Dayton—except the Chinese and a few hardcore placer miners—rushed to Sun Mountain to strike it rich. However, the miners at the head of Gold Canyon in Virginia City quickly learned that there was not enough water on the mountain to process the ore. By the fall of 1859, teamsters began hauling tons of ore to mills that were hastily constructed on the Carson River at the north and west end of the Dayton Valley.

By 1863, there were 18 hotels and restaurants in Dayton and the town was the commercial center and business hub of the Comstock. Like in most Nevada mining towns, however, life for Dayton's residents was based on a bust or boom economy. When the Comstock Lode ore's values diminished during the 1870s, only a few Dayton mills remained in business.

The construction of the Carson and Colorado Railroad and its depot in Dayton in 1881 spurred the economy, and political doings at the Lyon County Courthouse kept businesses going. Nonetheless, when the Dayton courthouse burned in 1909 and Nevada legislators voted to move the county seat to Yerington in 1911, a death blow was delivered to the town. While some mills created prosperity here in the early 1900s and later in the 1930s, Dayton's golden days had lost their luster.

Luckily, though, Italian immigrants had begun settling here in the late 1880s. They bought bottomland property and developed productive farms and ranches up and down the Carson River. This quieter lifestyle held the community together for 60 years.

Then, out of the blue, in the late 1980s and the 1990s, the valley began to change when an Arnold Palmer golf course and an urban-style subdivision were constructed in the southeast end of the valley. More and more people wanted to live in this pretty valley and the growth rate spiraled upward.

Now, Dayton Valley has three elementary schools, an intermediate school, a high school, a library, shopping center, and doctors' offices. At this time, the area is making a comeback after a national recession.

Through it all, Old Dayton Town remains a historic site that is well worth preserving for future generations.

One

WHERE NEVADA BEGAN

Eureka! While camping with a Mormon pack train at the mouth of Gold Canyon just above today's Old Town Dayton, Abner Blackburn made Nevada's first gold discovery in July 1849. The company was headed to California goldfields from Salt Lake City. Waiting for the snow to melt in the Sierra Nevada, and resting their stock, Blackburn took time to prospect. He later wrote: "I took a bread pan and a butcher knife and went out to the raveine to find gold in small quantities. Went to a larger raveine whear the watter run down over bedrock . . . found a fair preospect and kept panning for an hour or more . . . went back to camp, and all hands grabbed up pans, knives and kettles and started out. We scratched, scraped and paned until nearly sundown." Blackburn kept a journal of his Wild West adventures from the mid-1830s to 1851. It was published in 1992 by editor Will Bagley in *Frontiersman: Abner Blackburn's Narrative.*

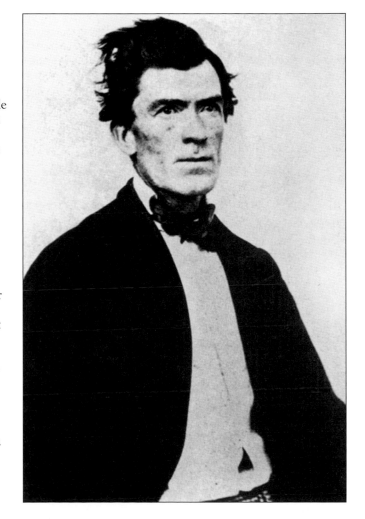

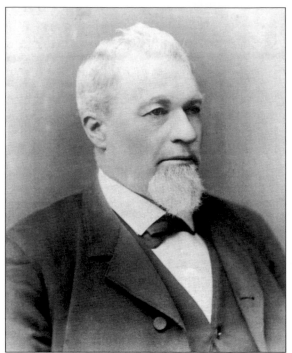

In June 1850, John Orr, a member of a Mormon wagon train on the way to Placerville, California, made Nevada's second major gold discovery when his party camped at Gold Canyon at present-day Dayton. Orr used a knife to dig a small nugget out of a crevice in the creek bed. He kept the nugget and it became a family heirloom, eventually passed down to his great-grandson Lt. Col. William D. Orr and his wife, Wanda. They later donated it to the Nevada State Museum, where it remains on display. The nugget weighs 19.4 grams and is one quarter of an inch in length and seven-eighths of an inch wide. It was worth $8.25 in 1850. Its value in 2014 was $875. A replica of the nugget is on exhibit at the Dayton Museum. (NSM.)

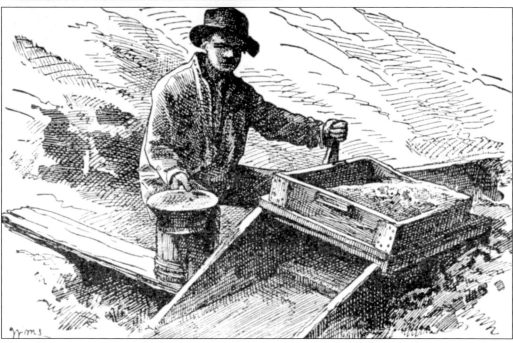

This illustration of an early-day placer miner prospecting in Gold Canyon depicts James "Old Virginny" Finney. The Virginia native was one of the first placer miners in the lower end of the canyon, possibly as early as 1850 or 1851. Finney was so admired by other Comstock miners that they voted at a town meeting to name Virginia City after him. He was said to be a hard-drinking man, but a skillful miner and an honest and generous person. An accidental fall from his horse while he was in Dayton ended his life in June 1861. Finney is buried at the Dayton Cemetery.

Sarah Winnemucca was one of the most remarkable women in Nevada history. She was born east of Lovelock, Nevada, about 1844. She learned to speak English, was an interpreter for the US Army, opened a school for Indian children, and became a respected lecturer and author. She testified in Washington about the plight of Nevada Indians. Winnemucca's book *Life Among the Piutes: Their Wrongs and Claims* (1883) reveals the story. She also had Dayton ties. Dayton historian Fanny Hazlett said that Winnemucca loved dances and probably attended Nevada's first dance, held at Spofford Hall's trading post at the mouth of Gold Canyon on New Year's Eve 1853. The event was attended by nine females, including young girls, and 150 miners, station keepers, and ranchers. Winnemucca sold her crocheted pieces to friends in Dayton in the 1860s. (NHS.)

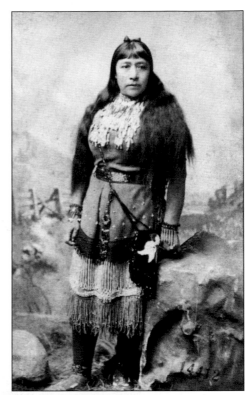

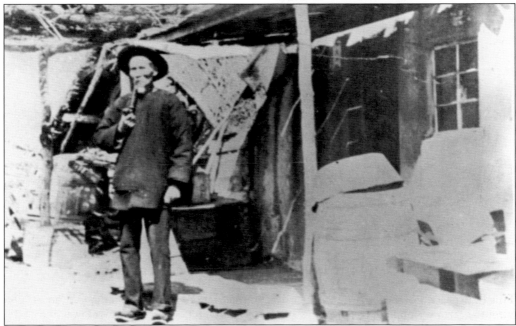

Chinese culture is embedded in Dayton history. In August 1857, Edward Rose hired and brought about 50 Chinese immigrants from San Francisco to Dayton to dig a four-mile water ditch from the mouth of the Carson River Canyon west of Dayton to provide water for placer gold miners working the diggings at the mouth of Gold Canyon. The ditch was completed in 1858.

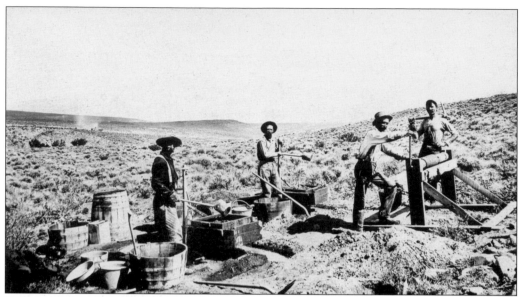

Early prospectors were stripping waste materials off of the ground's surface and washing the gravels buried below, using miners' expertise to search for old river channels bearing placer gold deposits. The wooden barrels, tubs, and tin buckets indicate the men carried water to the prepared site and poured it into a homemade rocker, which they used to separate the gold particles from the gravel. "Gold is where you find it," wrote Abner Blackburn, the frontiersman who found Nevada's first gold in 1849 at the mouth of Gold Canyon, where today's Dayton began. (Will Scott.)

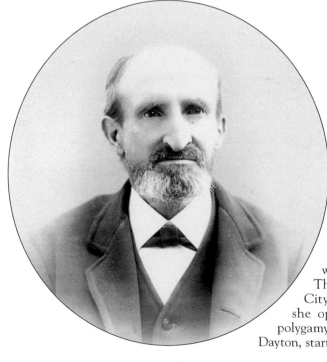

A devoted Mormon, Thomas R. Hawkins moved to the Dayton area with his wife, Nancy, and daughters Annie and Mary from Salt Lake City in 1862. Hawkins was a superintendent at the mining camp of Georgetown in the mountains south of Dayton. The couple's third daughter, Georgetta, was born there in 1863. At one time, Thomas wanted to return to Salt Lake City, but Nancy refused to go, saying she opposed the Mormon practice of polygamy. So the Hawkins family stayed in Dayton, starting a lineage still represented here.

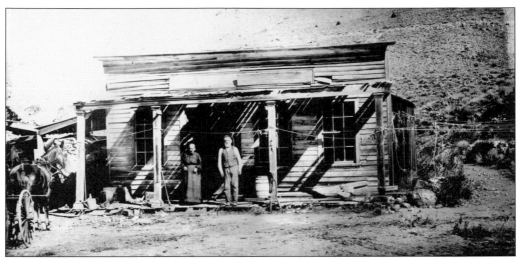

Gentle Annie and "Wild," or "Old," Bob owned the Briggs Saloon and store on the wagon road through Gold Canyon between Dayton and Silver City in the 1860s and 1870s. They specialized in selling Scotch pickles, sauces, and assorted condiments. During flush times, miners and socialites from Dayton to Virginia City shopped at the Swansea. When the boom ended, Bob and Annie's business did, too, and they took in laundry to make ends meet. One day, Annie's clothes caught fire, and her back was badly burned. While recovering, she crocheted lace items and peddled them herself. She was known as a storyteller; it was said that her stories "wouldn't look good in printers' ink."

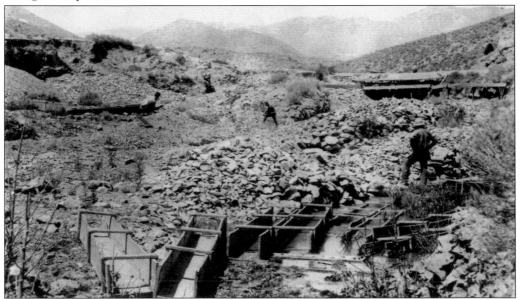

This early placer mining operation at the Brigg's Mill was in Gold Canyon, three miles above Dayton. Gold is concentrated in old creek beds; in time, geological events, such as flooding or erosion, change the course of the stream. These prospectors are searching gravel beds for the old gold deposits. The two men in the background collect samples of gravel, while the man in the foreground pans the samples, searching for colors. When gold is found, the miners assemble the wooden sections of the sluice box and wash the gravels of the old creek bed to recover it. (NHS.)

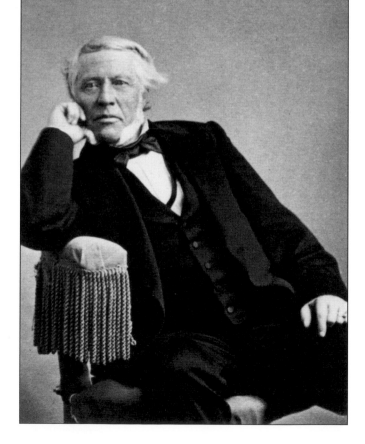

At the age of 13, James Scott, a British subject, went to sea and lived a seafaring life until age 25, when he was lured west to mine gold in California. His mining experience brought him to Gold Canyon in 1863 to supervise the construction of the Fred Birdsall and B.F. Leete Gold Canyon toll road between Dayton and Silver City. The original wagon road had followed the old Emigrant Trail up the steep hill past the cemetery, around a hilltop and a bluff to Silver City. The townspeople and teamsters rejoiced when the roadway was complete, because it shortened the distance to the mines on the upper Comstock. In 1875, James bought the materials and laid out the first water system for Dayton, which he operated until his death in 1896 at age 71. He and his wife, Mary, had five children, two of whom died in infancy. After James's death, Mary ran the Dayton Water Works and lived in their family home until her death in 1919 at age 80. Her son Will spent the rest of his life in Dayton.

Looking dapper in this portrait is John Day, Dayton's namesake. He surveyed and laid out the boundaries of the community in 1861, when it was known as Chinatown. Residents favored a name change, so they voted at a town meeting to call the town Dayton, in honor of Day. He was elected Nevada surveyor general in 1868, serving at that post until 1878. (NHS.)

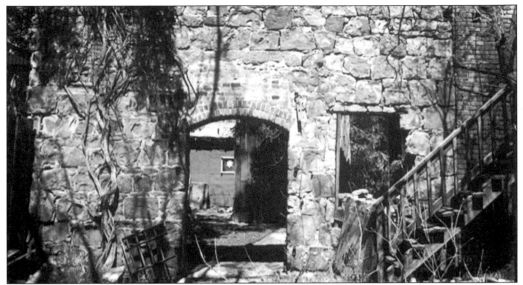

This rock wall is all that is left of a Pony Express station named Nevada City that was located on Dayton's Main Street in 1861. Today, the wall is still attached to the Union Hotel. The Pony Express Trail followed the path of the Emigrant Trail of the early 1850s. Riders going east went down Cemetery Road to the station, where they picked up the mail sacks, then they turned left on Pike Street and followed what is now the old US50 route to the west of the current Dayton State Park, and continued on the trail along the Carson River. Dayton was one of 190 Pony Express stations. Daring young men on horseback carried the mail between St. Joseph, Missouri, and Sacramento, California. Hell-bent to duty, the riders delivered the mail on time, deterred by neither blizzards nor Indian attacks. Privately owned, the Pony Express service lasted 18 months, from April 1860 to November 1861. Providing a faster way to deliver messages, the installation of telegraph lines across the country put the Pony Express out of business. (Laura Tennant.)

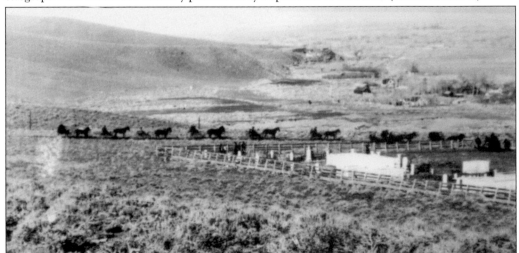

A funeral is being held at the Dayton Cemetery at a site that was officially designated in 1861. Pioneer settlers recalled when another burial ground was located just below the present cemetery on the hillside, but the gravesites began washing away and, with them, the remains of such notables as James "Old Virginny" Finney and George Claggett. Their remains were later moved to the official cemetery, and their tombstones are visible today. (Will Scott.)

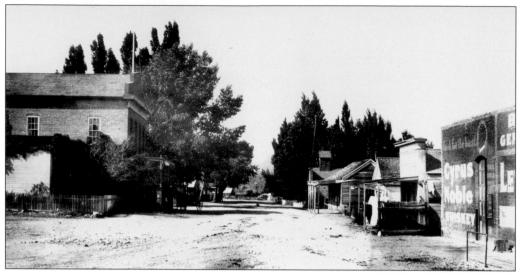

Old Town Dayton commerce grew rapidly on the old Emigrant Trail, pictured here in the late 1800s. Thousands of people passed this way from the late 1840s into the 1860s on their way to California. Imagine the dust the wagon wheels, horses, mules, and livestock stirred up on Dayton's well-beaten trails. This was the last leg of the 2,000-to-3,000-mile journey from back east. After crossing the 26 Mile Desert east of here, the pioneers gladly camped along the riverbanks while others panned for gold.

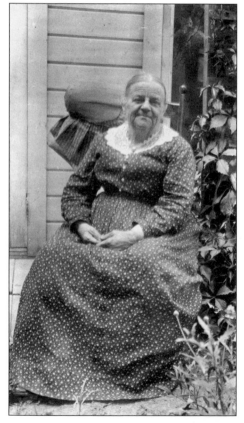

An important chronicler of early Dayton history, Fanny Gore traveled from Iowa in a wagon for four months before arriving at this boomtown in 1862. She lived with her brothers in a tent at a woodcutting camp in Eldorado Canyon south of Dayton before settling in town, where she lived for 52 years. Fanny married Dr. John Hazlett, and they had one daughter, Gertrude. An active suffragette, Fanny kept a diary about people, places, and things happening in Dayton from 1862 until around 1910. The Nevada State Historical Society published her memoir, "Historical Sketch and Reminiscences of Dayton, Nevada," in its 1922 book. A copy is available at the Dayton Museum.

Dr. John Clark Hazlett practiced medicine at his Pike Street home from 1862 until his death in 1895. A typical Old West doctor, Hazlett carried his black bag to homes to tend the sick. Dayton residents remembered him as a kind, generous man who treated rich and poor with dignity. His fees were based on a patient's ability to pay. Hazlett also had a law degree and served as Lyon County school superintendent (1866–1870) and state senator (1870–1874). He married Fanny Gore, also an 1862 Dayton settler, who later wrote an important memoir describing life in Dayton during its heyday.

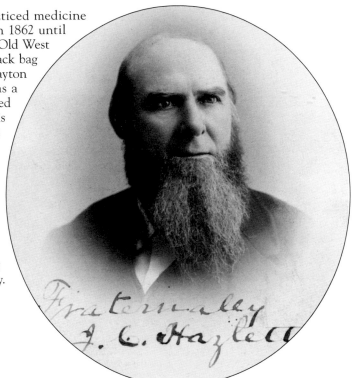

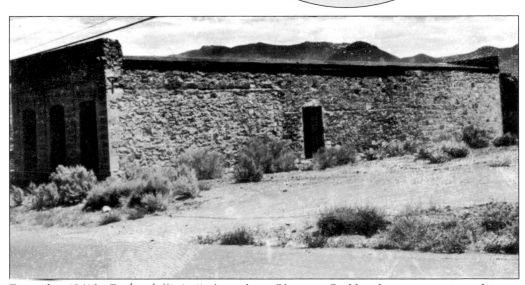

Erected in 1861 by Frederick Birdsall, the stalwart Bluestone Building has seen many good times. Originally Birdsall's mercantile store, it was the only building on Main Street west of Pike Street that survived the fire of 1866. At that time, businesses were built from the Carson River Bridge to the other side of the Bluestone Building. Birdsall had also manufactured bluestone here, which was used in the reduction of gold and silver in his quartz and tailings mill on River Street. Eventually, the rich ore bodies were played out, and when Dayton's population dwindled in the mid-1900s, the Bluestone stood in ruins. Residents rallied to save it in 1990, and Lyon County refurbished the structure, which now houses the Dayton Justice Court. (Laura Tennant.)

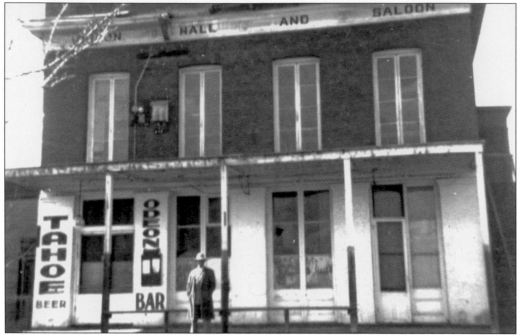

The first fraternity to organize in Dayton in Dayton was the Independent Order of Odd Fellows, which constructed the Odeon Hall building in 1863. After the devastating fire of 1866 gutted the structure, W. Byrom and L. Crockett rebuilt it as a restaurant and it was later named the Odeon Hall and Billiards Parlor. The structure burned again in 1870, was rebuilt, and eventually became the Odeon Hall and Saloon, as it is today. The Odeon has served the community as a restaurant, bar, boardinghouse, courthouse, jail, and a theater for film productions, town dances, and celebrations. Max and Mia Kuerzi, who ran a Swiss restaurant there for a couple of decades, still own the Odeon.

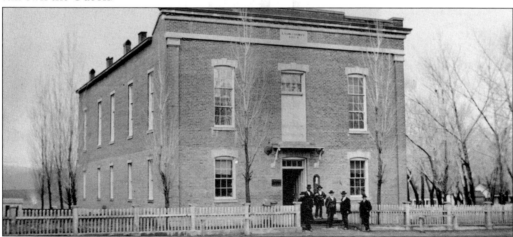

This grand two-story brick building, the first Lyon County Courthouse, was built in Dayton on Pike Street in 1864. Dayton was named the county seat in 1861, before Nevada became a state, but it was three years later when a building was constructed where business could be conducted. The Nevada territorial legislature authorized the county to sell $30,000 in bonds to finance construction of the courthouse. However, due to a number of political debacles, costs soared, and Dayton taxpayers faced a bill of $49,066, plus interest; the account was not settled until 1881.

Two

MINING AND
MILLING BOOM

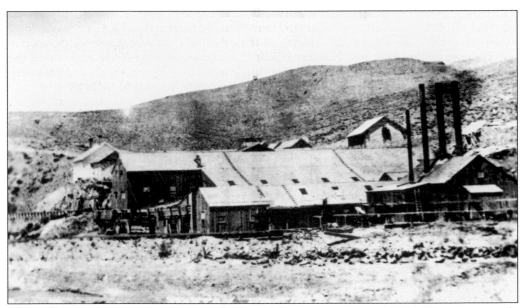

The mill at Rock Point, first built in 1860 or 1861, operated on a rocky knoll a quarter mile north of Dayton. It was one of the first quartz stamp mills built for the reduction of ore mined on the Comstock Lode. Historians describe it as "one of the most extensive establishments in the country," having a 90-foot-by-100-foot main building, a 100-horsepower engine, 42 stamps, with a dam and race (ditch bringing water from the Carson River). The mill, which cost about $10,000 to erect, employed 30 men. Its reduction capacity was 50 tons daily, processing ore from the mines of the Comstock. It was upgraded several times and burned down in 1882. Rebuilt, it was destroyed by suspected arson in 1909. Nonetheless, reconstruction started the same year, and the mill was again in operation by 1910. Affectionately called the Rocky Point by locals, some type of mill functioned at the site and provided jobs for Dayton residents until the 1920s, when the mill was dismantled and moved to Silver City.

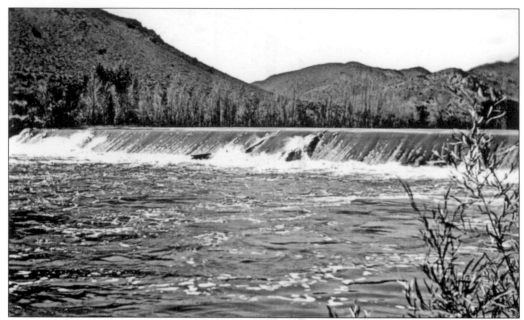

The volume of water flowing from this dam west of Dayton demonstrates why most local mills were built on the river in the 1860s and into the 1880s. Waterwheels on the river generated the power needed to operate the mills. However, the river was as unpredictable as the weather. In wet years, floods washed away the mills, equipment, and profits. During droughts, there was not enough water to generate power.

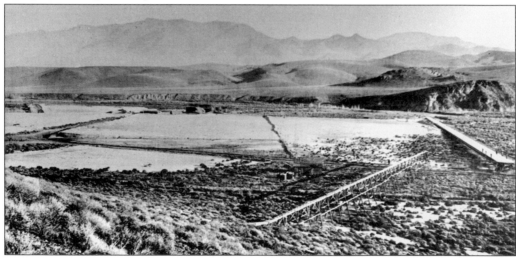

One of the first mills in operation after the discovery of the Comstock Lode in 1859, the Woodworth Mill began processing ore west of Dayton that same year. This site, where the Santa Maria subdivision is today, quickly became a popular spot for milling the Comstock's rich ore. The Hastings & Woodworth Mill, the first water-powered mill on the Comstock, also began operation here in 1859, as did the Carson River Quartz Mill. In the same area, a hamlet of 50 people was called the Fort Woodworth Camp. Ironically, one of the Carson River Quartz Mill owners, John Devon Winters, was the great-grandfather of JohnD Winters. Nearly a hundred years later, in the 1950s, JohnD and his wife, Kay, bought a ranch at the same site. The Winters did not know then that JohnD's uncles and his great-grandfather had also lived there. (NHS.)

The three Winters brothers—Theodore, Joseph, and John D. Jr.—were members of a Nevada family who have been prominent in the state's history since the gold and silver rush days of 1859. John D. was one of the lucky prospectors at the Ophir claim site at Gold Hill when the richest silver strikes on the Comstock Lode were found. Buying a one-third interest in the Ophir claim, John D. went from rags to riches when his claim assayed at $3,276 a ton. John, Joseph, and their partners hauled ore from the Ophir mine above Virginia City to their river-water-powered quartz mills at the west end of Dayton Valley. One of the Winters' mills at this site on the Carson River, the Hastings & Woodworth, was the first water-powered mill to crush Comstock ore. Prior to water-powered milling, mules or horses provided power for a primitive method of crushing ore. (Kay Winters.)

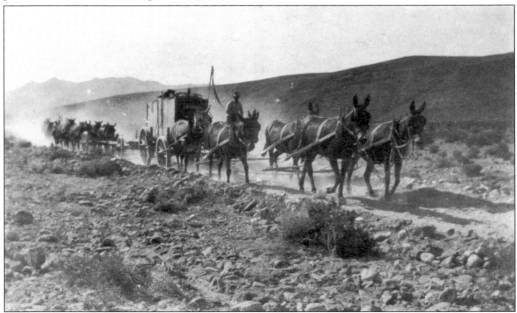

A jerk-line team hauls materials into Dayton from Virginia City, Gold Hill, or Silver City, located north of Dayton. The teamster has placed his best pair of mules in the lead while he rides behind the shorter set of mules to control them. The brake on the freight wagon has a long handle for leverage with a lanyard that the teamster pulls to apply the brakes. This teamster has his hands full, as he is also pulling a wagon trailer on wheels and a three-pair team of mules.

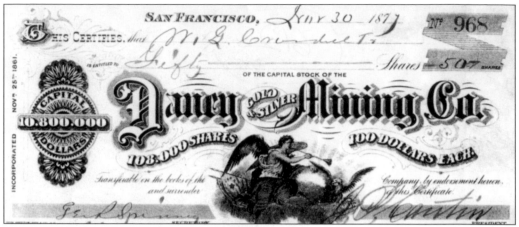

This Daney Gold & Silver Mining Company 1877 stock certificate represents just one of many investment opportunities offered by Comstock mining companies in the 1860s and 1870s. The investor, M.G. Crandall Jr., bought 50 shares of stock at $100 a share. Although the Daney Company had paid dividends of $56,000 over a seven-year span, the last payment to stockholders was in 1869, and indications are that Crandall lost money. The mine was located near the top of today's Dayton Hill, north of US50.

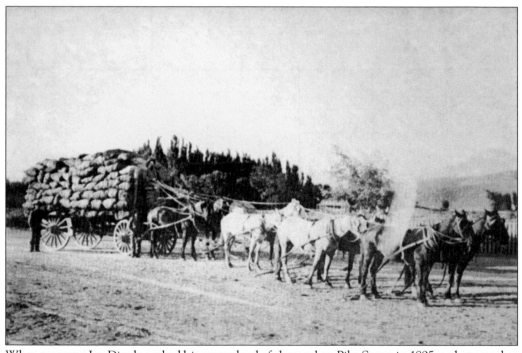

When teamster Joe Dingle parked his wagonload of charcoal on Pike Street in 1895, a photographer snapped his picture. The owner of the wagon, A.W. Stanley, stands at left. During Dayton's milling boom of the 1860s and 1870s, hundreds of freight loads of fuel wood and charcoal, used in smelting furnaces in Virginia City, were hauled from the Pine Nut Mountains south of Dayton. (Ray Walmsley.)

During the Comstock boom, the Dayton Lime Works kept laborers busy day and night, cooking in enormous kilns to make lime cement. This worker is charging the kiln's firebox. After the limestone was loaded into the upper section of the kiln, it was cooked, broken into pieces, and ground into powder to make lime-based cement, which was used to make mortar, stucco, or plaster. Built by J.C. Blanchard in 1875, the sandstone kilns were erected on top of two limestone knolls about 60 feet high. To fuel the ovens, the workmen used cordwood cut from pinyon trees growing in nearby mountains. (CHD.)

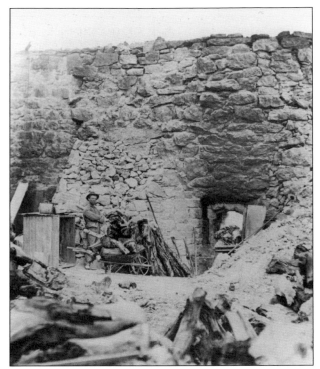

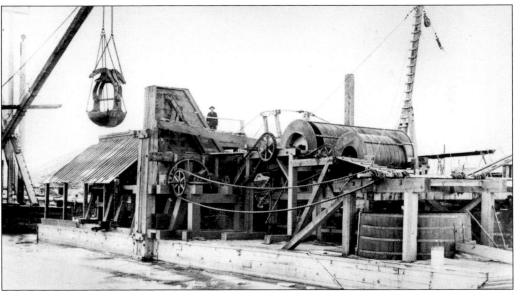

Between 1860 and 1880, millions of dollars of metals were lost in the river above Dayton due to the inefficiency of early milling operations. The first outfit to try to recover gold, silver, and mercury from the river bottom was the Carson River Dredging Company. J. Hanse Rae Sr., a speculator, formed the dredging company around 1878. Because river dredging demanded the best and most expensive milling equipment available, Rae built a barge, cyanide plant, and sturdy chains and buckets to drag the grimy gravel and rock up to the floating mill for processing. By 1894, Rae was losing money and hired Sacramento River dredging experts to remedy his problems. Nonetheless, despite Rae's upgrading his system, like in most river dredging, his profits were meager. (NHS.)

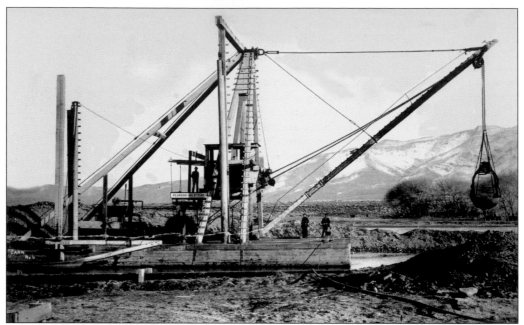

Nevada's first floating dredge was designed and constructed by J. Hanse Rae Sr. for use in the Carson River around Dayton. It was christened the *Dayton* at a ceremony in February 1889. Every Dayton resident attended, as did Nevada governor Charles Stevenson. Rae swung a sledgehammer to release the braces that held the 80-foot-by-50-foot rig to dry land, and the citizens cheered as it slid down planks into the river. Rae later hosted a luncheon at the Union Hotel on Main Street. He had estimated that his dredging project could net up to $400 million by recovering gold, silver, and mercury lost in the deep river bottom in earlier milling endeavors. Although Rae's dredge was renovated a few times, and he mined the river until around 1915, profits were meager. (NHS.)

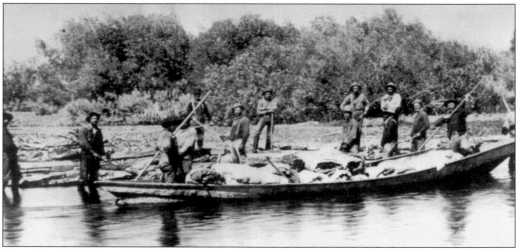

From the 1860s through the 1880s, the woodcutting business was a moneymaker. Woodmen cut timbers from the Sierra Nevada forests for use in the Comstock mines 30 miles away. The logs were floated down creeks to the Carson River near Carson City and then guided farther downstream to Dayton. From there, the wood was hauled by wagon to the Virginia City area for building and firewood. The boat in the photograph contains the workmen's bedding and clothing, as the men camped alongside the river near the worksite. (NSM.)

Moving to Dayton in the early 1890s from the Sacramento River area, where he earned his captain's certification, Capt. Herman Davis was hired to manage a Carson River gold-dredging operation. He went on to become a mill owner, and his industrial milling enterprises brought prosperity to the town for 20 years, even after the glory days ended. Having a limited education, Davis struck out on his own at age 16. He was industrious, enjoyed learning, and, in later years, patented a number of inventions that improved the cyanide process of extracting metals from ore, which he used at his Davis Chloro-Cyanide Plant.

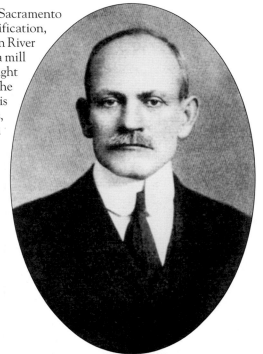

These teamsters are dumping wagonloads of old tailings, or low-grade ore, into the tanks inside the building, to be processed at Nevada's first cyanide milling operation. The Davis Chloro-Cyanide Plant occupied a site near the river, close to today's Second and Third Avenues and US Route 50. Capt. Herman Davis and a partner, J.C. Pierson, built the state-of-the-art cyanide-processing plant around 1897 to recover gold and silver that had been lost in earlier, more primitive milling operations. The manufacture of cyanide had been perfected in South Africa and Scotland in the 1890s, and Davis was the first to use the technology in Nevada. Milling expertise had come a long way in just 40 years, since the time when the earliest mills in the valley crushed Comstock Lode ore using arrastras powered by mules.

With its proximity to the Carson River, Dayton was a milling center for processing the Comstock Lode's high-grade silver and gold ore, primarily between 1862 and the 1880s. Hauling ore from the Comstock mines to Dayton mills in heavy wooden wagons pulled by mules, these teamsters made several round-trips each 12-hour workday, seven days a week. (Adele Englebrecht.)

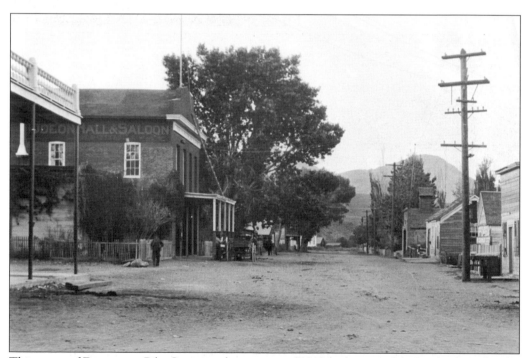

This scene of Dayton on Pike Street in the summer of 1909 looks peaceful. On the far right, the fire station that has existed since 1875 is the last building before the trees. On the left, a wagon is parked in front of the Odeon Hall, one the oldest buildings in Nevada.

D.W. Roberts (left) and Arthur Geary prepare to do electrical work on large transformers at the Douglass Mill in 1905, the year the Truckee River Power Company brought dependable electric power to Dayton. Before then, the Douglass Mill operated on power generated by the Carson River. Most mills built before 1905 were constructed on or near the Carson River, thus floods destroyed them and in dry years waterwheels used to generate power were useless. Steam power was more dependable, but frequent accidents caused by ruptured boilers or steam lines often killed or injured employees and ruined equipment. Later, electricity in Dayton replaced the need for local mills to use water and steam to generate power.

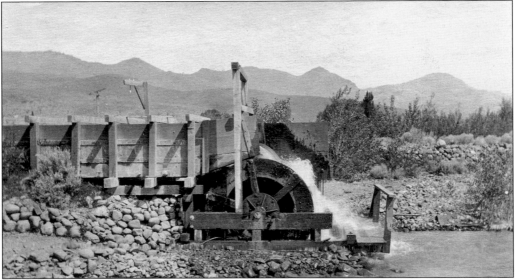

In the 1800s, the success of a Carson River mill depended on its waterwheel. Here, the wood-framed flume brings water from a dam to a waterwheel, which supplies the electrical generator that powers the mill. Because Dayton Valley is flat, dams were necessary to elevate the water. To further increase the water's force, flumes were the same width as the wheels. Even after electricity came to Dayton in 1905, it was expensive, and waterwheels still ran some mills.

This serene scene on lower Gold Canyon Creek does not reflect the furious activity that followed a gold find in 1849 at the canyon's mouth at Dayton. This discovery led to the founding of the Comstock Lode 10 years later. The creek begins above Virginia City, joins the American Flat Creek at Silver City, and then meanders through a picturesque canyon above Dayton before ending at the Carson River. (Lawrence Lothrop.)

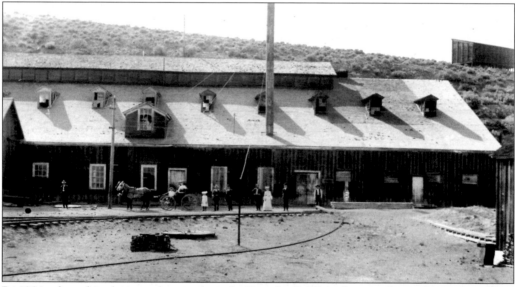

By 1904, when this photograph was taken, the Douglass Mill on the west slope of River Street had extracted gold and silver worth hundreds of thousands of dollars from quartz ore and reworked tailings. Frederick Birdsall and a partner had built the Birdsall & Carpenter Mill in 1861–1862. Later, Birdsall bought out his partner and renamed the facility the Lyon Mill. He also expanded the mill. In 1869, Birdsall converted it to a tailings mill and built a horse-drawn railroad to the foot of Gold Canyon to move tailings to the mill. In 1881, he modified the railroad to a narrow gauge, connected it to the new Carson & Colorado Railroad, and added two small locomotives. Nonetheless, in 1882, he sold the mill to Joe M. Douglass of Silver City, who changed its name to the Douglass Mill. Douglass renovated and enlarged it and significantly increased the length of the railroad past Sutro to the old Carson Valley Mill site. The newly named Dayton, Sutro & Carson Valley Railroad ran until around 1896. Pictured here are, from left to right, Hense Rae, Billy Douglass (in buggy), Carrie Rising, Stanley Rising, Isabel Rising, Manly Johnson, a Mr. Washburn, J.H. Rae, Louise Rae, Leete Blanchard, and Adam Schock.

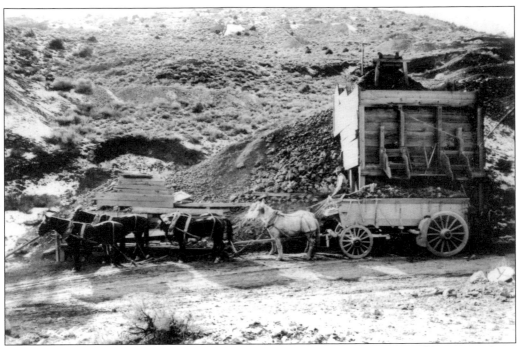

At the Hartford Hill mine in Silver City, four miles above Dayton, a teamster and his wagons have received nine tons of material from an ore bin built on the side of a mountain. The ore was being hauled to a Dayton mill. Mine owners and mill men often formed partnerships, so that a miner's ore was processed at an associate's mill. Mining and milling brought unprecedented prosperity to Dayton from the 1860s to the 1880s. (Special Collections, University of Nevada, Reno.)

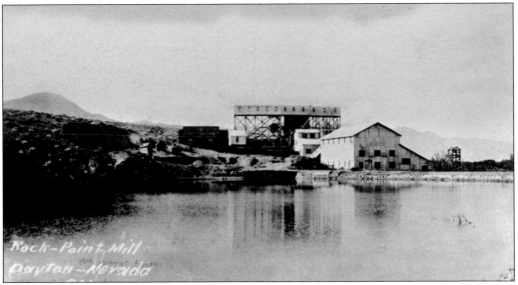

After suspected arson in 1909 destroyed the Nevada Reduction Works, formerly the Rock Point Mill, owner Capt. Herman Davis had it rebuilt. Nevertheless, he sold it in 1910 and moved his family to Reno. Shown here in 1911, with its reservoir filled to the brim, the new mill was a beauty. Sadly, though, within 10 years, the mining boom had ended and the Comstock's bust was in progress. (Ray Walmsley.)

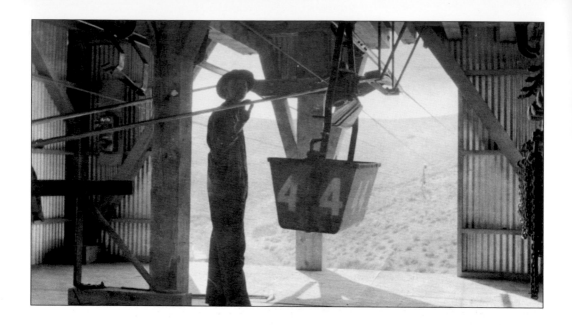

These photographs show the interior workings of an aerial tramway, a new approach to transporting ore to an existing mill. The tramway was erected by the Hotaling Estates Company to expand its Nevada Power & Reduction Works mill north of Dayton. The tramway carried buckets of ore across the mountains, four miles from the Haywood Mine in Silver City. Above, a workman watches the empty bucket slide along a cable that will take it back to the mine for a load of ore. The below photograph displays the ore-loading chutes at the Haywood Mine. As a way to cut the high costs associated with hauling ore using freight wagons from mines to mills, progressive mill men in the West began using aerial tramways between 1907 and 1920. (Both, Special Collections, University of Nevada, Reno.)

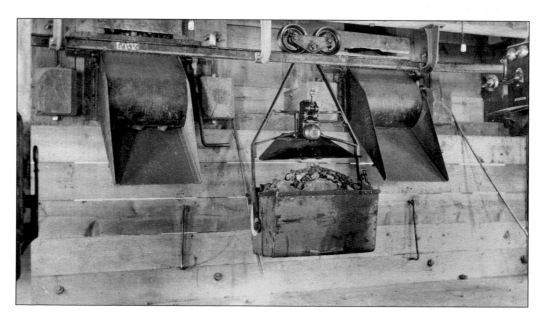

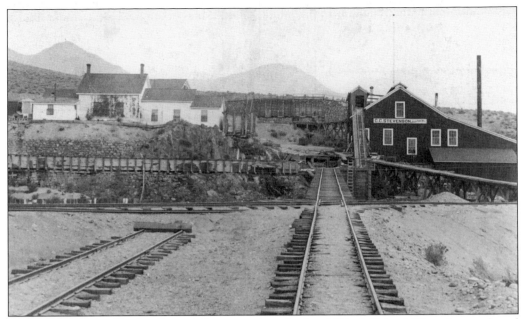

In the early 1880s, Charles Conrad Stevenson bought the old Rock Point Mill at the north end of Dayton. In 1882, a fire completely destroyed the mill. Undaunted, Stevenson rebuilt the mill, greatly improving it and installing two huge waterwheels, which allowed the mill to generate additional power and process more ore. In 1885, Italian farmers in Dayton Valley sued Stevenson, charging that he raised the water in the mill's dam on the Carson River so high that it overflowed and ruined their crops. Stevenson was elected Nevada's governor in 1886, but he continued milling in Dayton until his death in 1890.

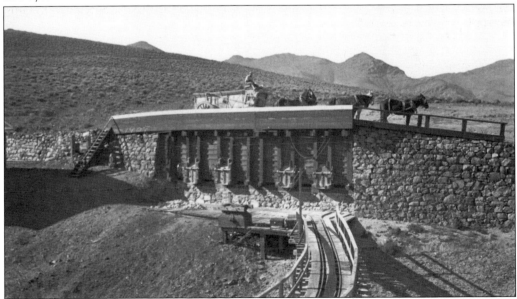

A teamster dumps ore from Silver City into bins at the Rock Point Mill. The ore was then was dropped into ore cars and moved a short distance to the mill for processing. Today, little is left of the Rock Point Mill ore bins and its elaborate rock wall, built with stone from a nearby quarry. The millsite is part of Dayton State Park and is open to the public. (NHS.)

Teamsters working at the Rock Point Mill north of Dayton in the early 1900s have unloaded wagons filled with tailings at a site across from the Gold Ranch Casino on US50. Laborers had spread the tailings into windrows to dry. Since there might be values left in the tailings, they were saved and re-milled.

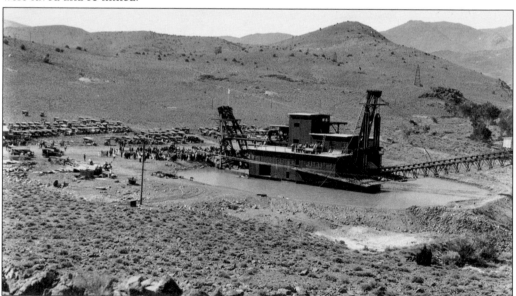

Excitement reigned on September 20, 1920, when 2,000 people gathered to christen the Gold Canyon Dredging Company's plant a mile west of Dayton. Vida Boyle, wife of Gov. Emmet Boyle, threw the switch to begin the gold- and silver-mining operation. Hundreds of automobiles surrounded the 900-ton dredge, and many of the ladies dressed in silk gowns. The company bought two houses in Dayton to board employees, a clubhouse, and an office, and installed a water system and cisterns for fire protection. After three years of operation, the company had made a profit of $750,000. However, the project was abandoned three years later. (NHS.)

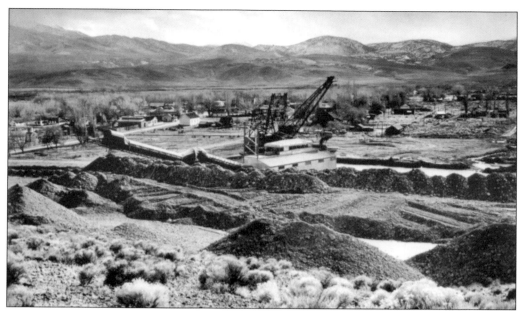

This view of downtown Dayton in the early 1940s does not indicate the tremendous size of the equipment used by the Dayton Dredging Company. Its gold-recovery project included digging out a large section of the original Gold Canyon diggings of the 1850s and 1860s and obliterating most of the town's original settlement. The humungous dragline bucket used to scoop materials from the bottom of the pit became a tourist attraction. "You could drive two pickups into that bucket side by side," recalled Dayton native Ray Walmsley, a cat skinner for Dayton Dredging. He added, "One bucket load lifted hundreds of tons of gravel and rock. To balance the machine, 145 tons of ballast was placed in the rear of the dragline." The dredging operation began in 1939, after the company bought and relocated a dozen of Dayton's oldest homes. The company employed around 70 men and ran three shifts. (NHS.)

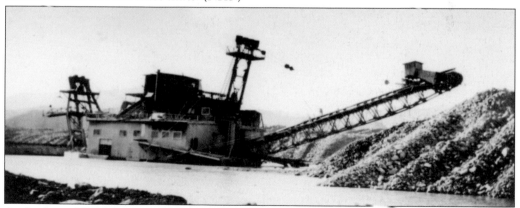

At the foot of Gold Canyon, the Dayton Dredging Company began searching for gold in Dayton in 1939 after the company bought and relocated a dozen of Dayton's oldest homes on the west side of town. The pile of loose rock stacked next to the dredge continued to grow as the dredger dug deeper and deeper for more than three years into the mountainside. It is still visible from Pike, Second, and Third Streets. The company employed around 70 men and ran three shifts. Raymond "Ray" Walmsley and his wife, May, lived nearby: "The humming of the electric motors that operated the dredge echoed through town day and night." Ray added, "That dredge spoiled the look of the town. It ruined its history and character." (NHS.)

The Samuel and Lela Stevenson family, among the earliest settlers in Dayton, is pictured outside their home, built on the Emigrant Trail, which ran through town during the California Gold Rush days. Lured by gold miners' stories, Stevenson arrived in Dayton in the late 1850s. Today, the house on Cemetery Road is the residence of Johnye and Steven Saylor and the site of Evergreen Studios, where Saylor paints and sells his artworks.

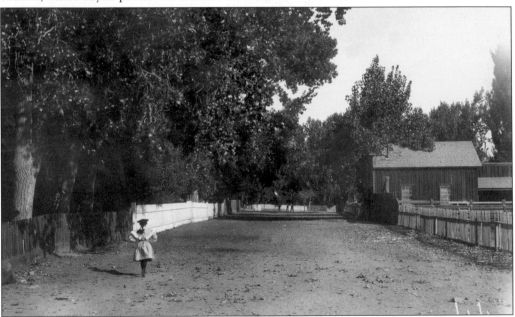

This quiet residential scene on Shady Avenue in Dayton in the late 1890s no longer exists. When the Dayton Dredging Company came to town to search for gold in 1940, its equipment dug up the west end of town. The company bought, tore down, or moved the homes from the site. Today, the street, called Shady Lane, has a few homes on its east side. On the street's west side, nothing remains except unsightly piles of boulders and rock, left by the dredger.

A Prussian immigrant, Adolph Sutro arrived in Dayton from San Francisco in 1861 and erected a small mill on the Carson River, near today's Railroad Street. By 1863, it had become a large steam-operated and efficiently run operation. In one month, Sutro netted a profit of $10,000, but the mill burned down in 1863. By then, Sutro was obsessed with finding investors to pursue his plan to excavate a tunnel between the town of Sutro and Virginia City.

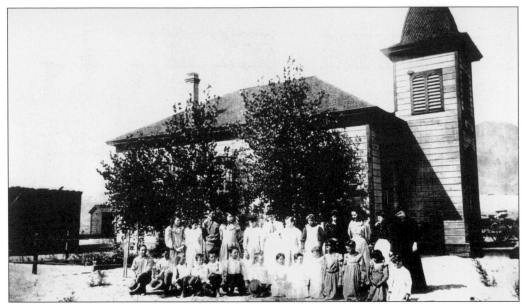

This rare photograph shows the town of Sutro's classy schoolhouse. By 1876, Sutro had reached its peak of 800 residents, with businesses, a church, and the *Sutro Independent* newspaper. By the early 1900s, the buildings had been moved and the schoolhouse was torn down. The barbershop building was moved to Dayton. Today, a few residences occupy the old Sutro Tunnel site and a modern subdivision and new Sutro School mark the old townsite.

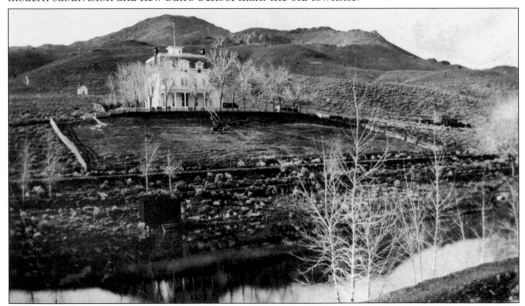

Adolph Sutro's two-story Victorian mansion, built in 1872, looked magnificent on the hillside overlooking the town, Carson River, and the pond, where frogs, ducks, turtles, and trout resided. Sutro wanted plenty of frogs for eating so he purchased, via express mail, a dozen frogs for $2.25. However, since it was difficult to tell the gender of a frog, he had no idea if they would reproduce. The mansion cost $40,000 to build and furnish, and it was heated with gas radiators. Sutro, his wife, Leah, and six children lived here until 1879, when she and the children moved to San Francisco without him. The mansion burned in 1941.

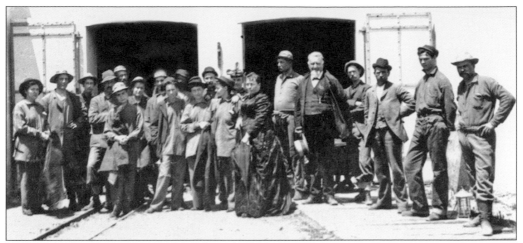

On October 29, 1870, while waiting for a tour through the Sutro Tunnel from Sutro to Virginia City, several dignitaries were photographed at the portal of the tunnel. Due to misty conditions inside the tunnel, Adolph Sutro's guests usually wore "tunnel clothes"; they often left a change of clothes at their hotel in Virginia City.

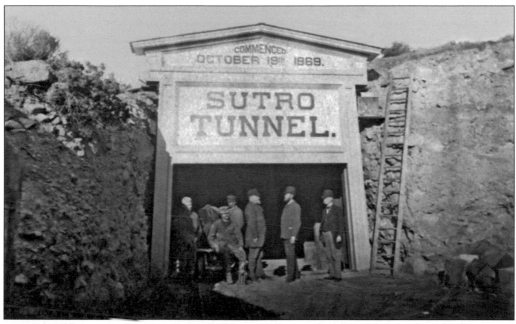

In the mid-19th century, Virginia City's mining industry spurred technological and engineering breakthroughs, including the construction of Adolph Sutro's tunnel in 1869. When Sutro learned that hot water seeping into the Virginia City mine shafts was causing the industry lost time and money, he engineered the construction of a tunnel between Sutro and Virginia City that would drain the water from the shafts. Sutro found investors and raised funds to build the tunnel. Construction on the four-mile tunnel began in October 1869 and was not completed until July 1878. By then, Comstock mining was on the decline, so, before the tunnel was finished, Sutro had sold his stock for more than $1 million, which he invested in San Francisco, where he became mayor and spent the rest of his life.

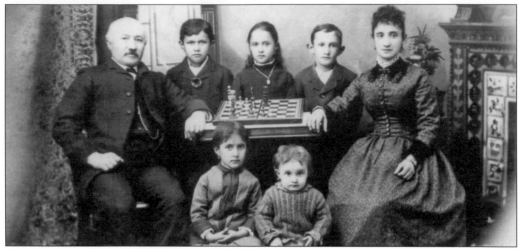

The Alexander Summerfield family had its photograph taken inside Adolph Sutro's opulent mansion at the site of the Sutro Tunnel, located near today's Sutro Elementary School in Dayton. Alexander owned the Summerfield Store at Sutro City when the tunnel to Virginia City was under construction in the 1870s. Shown are, from left to right, (first row) Hattie and Myrtle; (second row) Summerfield and his children Solomon, Rose Esther, Abraham, and Alexander's wife, Esther. Summerfield gave the welcoming speech when Pres. Ulysses S. Grant toured the tunnel in 1879. The *Sutro Independent* gave his speech rave reviews. Summerfield's speech concluded as follows: "I echo the sentiment of every child, woman and man in the town of Sutro, for, General, we love you. In a short time, you will behold one of the great enterprises of the world, constructed by these brave, hard-working men."

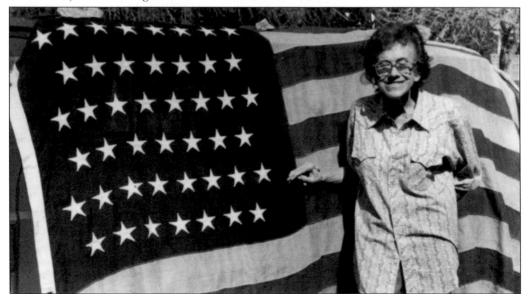

Angela de Nevi attended the Sutro School around 1914. She is seen in later years with the 45-star American flag (the official US flag from 1896 until 1908) that flew over the schoolhouse during her school days. She found the flag in a pile of trash left behind when the school was torn down in 1935. De Nevi graduated from Dayton High School and the University of Nevada School of Journalism and wrote a gardening column for the *Nevada State Journal* for many years. (Laura Tennant.)

Three

A COMMERCIAL CENTER

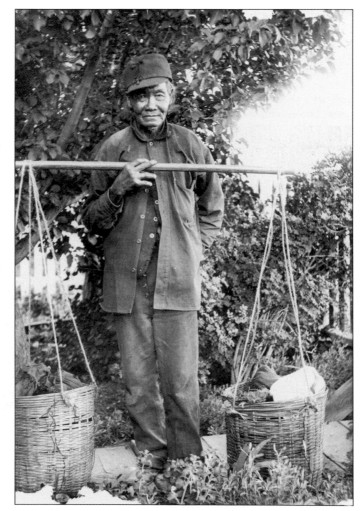

Huong Lee, called "Hully" or "Holly," was a familiar character to old-timers who lived around Dayton, Virginia City, Mound House, and Sutro, where he walked from house to house, peddling his wares. During the early 1900s, Hully sold fruits, vegetables, candy, nuts, and shrimp. "He was never without shrimp, and carried the load in the two baskets slung on each end of the pole that he carried over one shoulder, a feat that would tax the strength of any man twice his size," said his friend Zenas Walmsley, who added, "He was supposed to have been born in Kingston, Ontario, Canada, the offspring of a Chinese father and an Indian mother and supposedly 100 years old, or older, when he died in 1916."

This building, known as the "old trading post" by Dayton old-timers, might be the first permanent trading post built on the Emigrant Trail, by which travelers passed through Dayton on their way to Sacramento from the 1840s to the 1860s. A Nevada Historical Marker highlights the site of the building at the west end of Main Street. The building was destroyed by a gold-dredging company in the early 1940s.

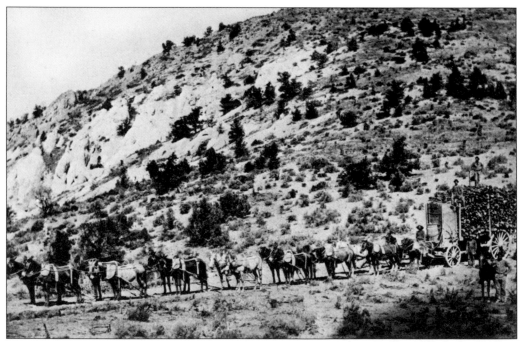

A 16-mule team pulls a gigantic wagonload of pinyon cordwood from the Eldorado Canyon, south of Dayton. In the 1860s and 1870s, an estimated 1,800 cords of wood a day were hauled from nearby mountains to provide power for steam engines running the dozens of stamp mills on the Carson River. Woodcutters also sold firewood to hundreds of new people arriving daily in Dayton and around Virginia City. (Pat Neylan.)

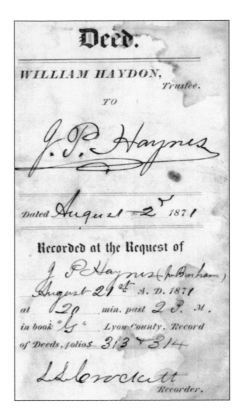

James P. Haynes, town carpenter in the 1860s, was resting at the front entrance of his shop when someone took the below photograph. The shop was located on the south side of Gold Canyon Creek, near the bridge at Shady Lane. In 1871, Haynes received a deed of ownership for two Dayton properties, one on Second Street and another on Main Street. Nevada legislators issued Haynes's deed, seen at right, after Congress authorized a US patent of land ownership for Dayton. Haynes's deed may be the only existing copy, because the Lyon County Courthouse burned down in 1909, and almost all of the court records were lost.

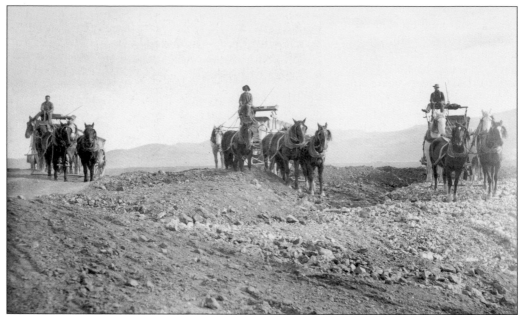

Dayton was the milling and woodcutting freight center of the Comstock in the 1860s to 1880s, when around 20 stamp mills were crushing ore throughout the valley, day and night. By 1862, hundreds of teamsters, with "bell teams" drawn by 12 to 22 mules or horses, spent their nights in Dayton. "There was music in the air, both vocal and instrumental, when they arrived," writes Fanny Hazlett.

This view of the east end Main Street in Dayton in the 1890s shows the downtown business sector from Pike and Main Streets to the Carson River Bridge. The scene also reflects a time when the roadway was the main section of the Emigrant Trail, which pioneers crossed on their way to California. The Union Hotel is on the right, and the Loftus Mercantile is to the left.

Garfield was a respected member of the Dayton community and known to be a kindhearted man. He is seen here inside his well-stocked Chinese mercantile in the late 1880s. He or his family may have dated back to Nevada's first Chinatown, which developed in the late 1850s along the Carson River around today's Silver and Railroad Streets. Garfield had joined the mining culture. He dressed in dungarees and had cut off his queue to wear a felt hat, and old-timers said he was proud to own and smoke a trendy clay pipe. A skilled chef, Garfield cooked at restaurants and at woodcutters' and charcoal makers' camps in the mountains, and he cut and sold firewood. (Geraldine Johnson, *Mason Valley News*.)

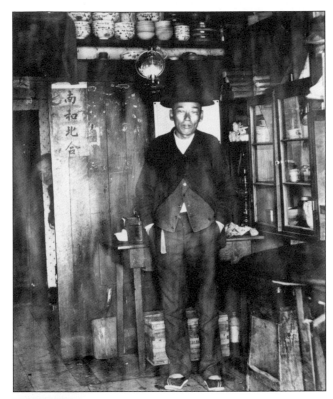

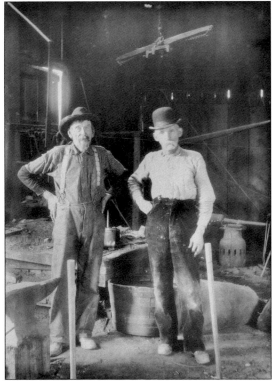

George Perry Randall (left), Lyon County sheriff, and Silas Cooper, a town smithy, pose in the Cooper and Box blacksmith shop, on the northwest side of the Carson River Bridge, in the 1880s. Hanging above Cooper's head is a hoist to move heavy, red-hot steel objects from the forge to the anvil. The forge is behind Randall. The major part of a blacksmith's work consists of wagon repair, where lifting heavy steel parts is dangerous work. Cooper's left hand is missing part of a finger and his middle finger is badly damaged. (Mel Cooper.)

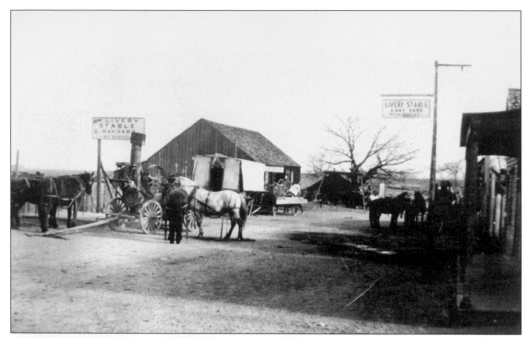

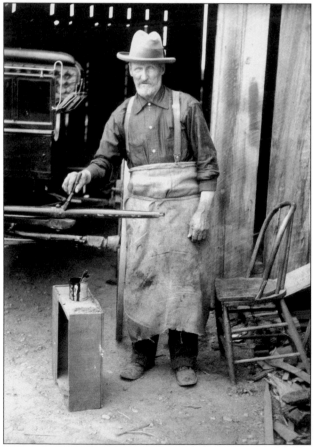

At left, William "Bill" Schooley paints a buggy at his Dayton feed yard and livery stables in the early 1900s. Besides caring for customers' horses and mules, he also rented horses, buggies, and larger conveyances at the stables, which took up a large city block between Main and Silver Streets, as seen above. Dayton was at the crossroads to the Sierra Nevada, the Como mining district, and the Comstock towns up the canyon. With woodcutters and ore-hauling teamsters on the road constantly, Schooley was busy day and night.

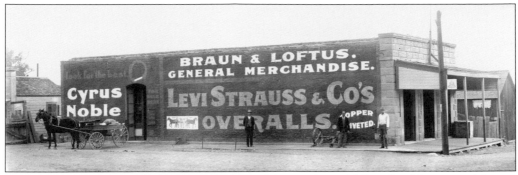

Posing for posterity outside the Braun & Loftus Mercantile are Nellie, the deliveryman's horse, and the owners, Jack Loftus (center) and C.C. "Charles" Braun (second from right). Clyde "Doc" Legg stands at far right holding a bucket. One of Dayton's oldest buildings, this stone structure survived major fires in 1866 and 1870. Over time, the building has housed saloons, a grocery store, an auto-mechanic shop, a gas station, and an ice-cream parlor. In 1999, when Dayton celebrated the 150th anniversary of Nevada's first gold discovery, Levi Strauss & Co. hired a professional to repaint the vanishing sign. Today, J's Bistro, an Italian restaurant, occupies this building. (Lawrence Lothrop.)

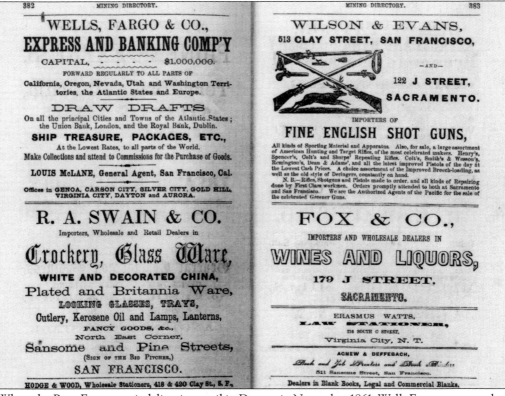

When the Pony Express quit delivering mail in Dayton in November 1861, Wells Fargo stagecoaches took over in the winter of 1861–1862. The company's agent, Fred Birdsall, had his office in the Bluestone Building on Main Street. He offered Wells Fargo's financial and delivery services to Virginia City and San Francisco. Later, the office was in the old firehouse and jail building on Pike Street. A cross-country ride cost $300 and took two weeks. As early as the 1850s, Dayton was an east and west mail stop for emigrants.

Downtown Dayton was a flourishing transportation and freighting center for immigrants and milling operations when George Perry Randall arrived via wagon in 1874. Here, Randall stands next to a wagon he is repairing at his blacksmith shop. His livery stable occupied a city block, where the Carson & Colorado Railroad depot is today on Main Street and US50. Randall was elected Lyon County sheriff in 1882, and the family ran a big spread at the Randall Ranch, where the Dayton Valley Golf Course is today.

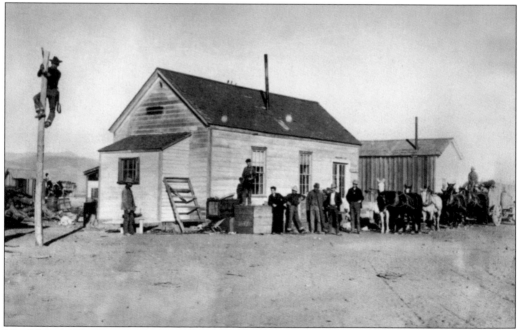

Neighbors gather to watch a resident climb a primitive power pole to bring electricity to his Dayton home. In 1905, when electrical power came to town, the Truckee River General Electric Company, based in Reno, extended power lines to Dayton. The power came from a hydroelectric plant on the Truckee River.

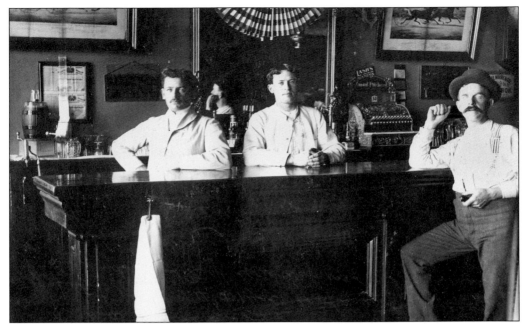

This 1870s photograph of the Union Hotel bar depicts its original elegance. Pictured are proprietor Will Gruber (left), Emerson Joy (center), and Dick Cornish. The former Union Hotel, today a private residence, is located on Main and Pike Streets in the heart of downtown Dayton. It is still revered for its longevity.

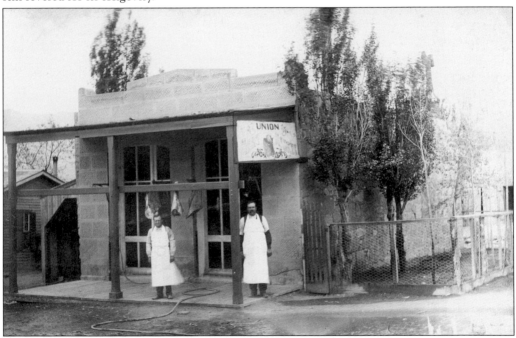

Eugene Baglin (left), a rancher and butcher, and Eugene Howard (right), the proprietor of the Union Meat Market and slaughterhouse on Main Street, were successful Dayton businessmen. A 60-year Dayton pioneer, Howard raised his family here. He owned two ranches, one in town and another on the outskirts. Today, a dog-grooming business operates here. (Lawrence Lothrop.)

Susan "Susie" Lothrop, daughter of John and Mary Malinda Lothrop, had lived in Dayton since 1875. She and Charles "Charlie" Braun were married in Dayton in 1894. Charlie settled in Dayton in 1872 and had been a miner and farmer before he entered the mercantile business. Of his love for Dayton, he said, "Before the grim reaper calls me, I will still be a citizen and businessman in Nevada." He and Susan are buried at the Dayton Cemetery.

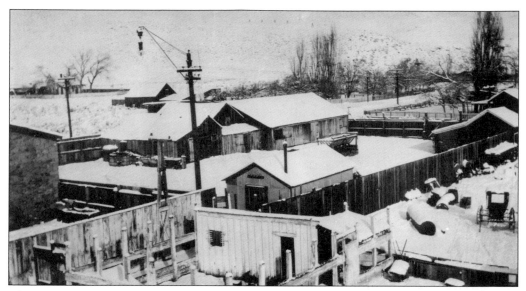

This 1913 snowy-day scene in Dayton is located between Second and Third Streets. The photograph shows the Nevada Reduction Works & Power Company's backyard, including a stable (left) and a blacksmith shop (rear right). The homes among the trees are on Pike Street. Today, the one original house on the old Walmsley dairy farm remains. The outhouses from the farm were moved to the Dayton Museum grounds on Shady Lane.

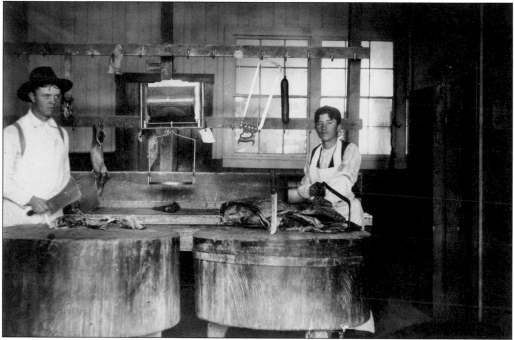

On July 4, 1905, at the Union Meat Market, Lawrence Lothrop (left) and Thomas Conway stand still while waiting for the camera's click. Born in Dayton, Lothrop was an admired town photographer. Sadly, the 22-year-old died the same day this photograph was taken. Many of his photographs are part of the Historical Society of Dayton Valley's collection. Lothrop is buried at the Dayton Cemetery in the family plot.

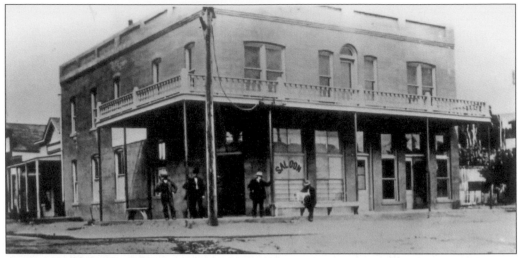

Around 1906, the Quilici Saloon and hotel, built by Michele and Maria Quilici, opened at the corner of Pike Street and Old US50 in downtown Dayton. (In the 1920s, the Lincoln Highway ran through Dayton.) Quilici had immigrated to Nevada in 1870 and staked a lucrative gold claim in Silver City, which enabled him to invest in Dayton. He married Maria Pedroli of Silver City, and they had five children—Peter, Emanuel, Celia, Hugo, and Alva. The children attended Dayton schools and went on to college. By 1913, the Quilici Mercantile Company had been formed and was operated by Peter Quilici. Hugo later became Reno's mayor, and his daughter Janet Quilici Swobe lives in Reno today. When arson destroyed the building in 1981, it was a terrible blow to the community. (Will Scott.)

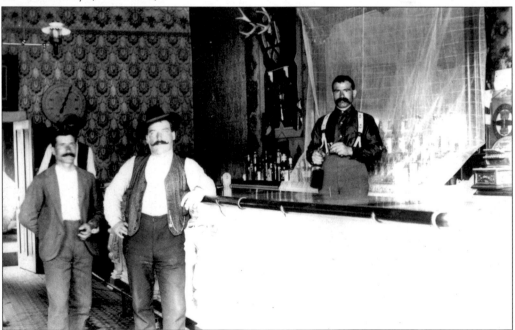

At the Odeon Hall saloon on Pike Street, bartender Serafino "Cookino" Dominici and his customers pose in the early 1900s. Dayton resident Zenas Walmsley said, "The big man in the front of the bar is Sixy Ka Ducy, an Italian gambler." Gambling was a favorite pastime in Dayton as early as the 1850s.

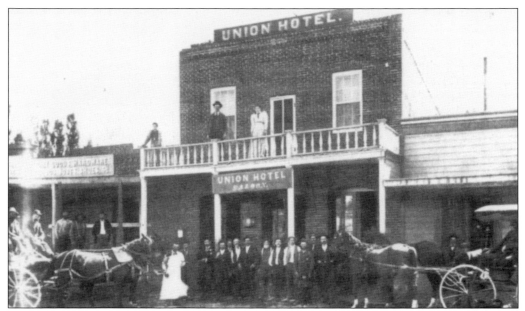

Posing for a photographer in front of the Union Hotel, these well-dressed folks must be celebrating a special occasion. History buffs wish the hotel could tell tales about the hundreds of pioneers who stopped for food, drink, or lodging during the town's early years. The 1870 hotel is one of Nevada's most endangered buildings.

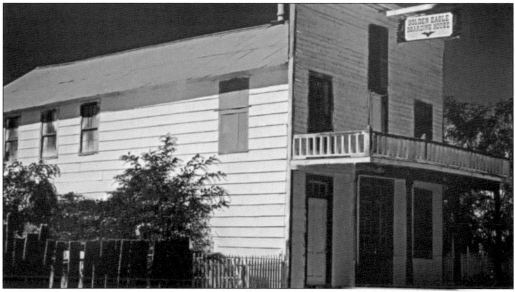

The Golden Eagle Hotel and boardinghouse on Pike Street was the oldest house in Dayton when it burned beyond repair in 1986. Built in 1862 by James Jaqua when Dayton was still part of Nevada Territory, the 10-room hotel could host 80 boarders during Dayton's golden years. Pete Pachetti and a partner, a Mr. Bartholemew, revived the boardinghouse in the 1920s. During Prohibition, imbibers could always find an alcoholic drink here. In the 1980s, Todd and Cheri Scott bought the hotel and discovered that an old cellar under the boardinghouse had a secret door that revealed what looked like a mine tunnel, with boards, dirt, and rocks for support. (Geraldine "Geri" Johnson.)

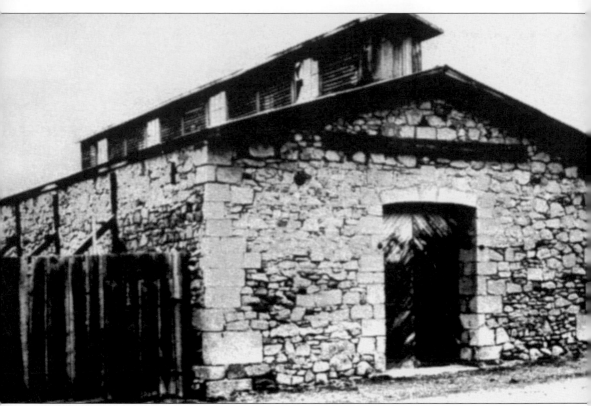

George Leslie Sr. and his wife, Ann, moved to Dayton from Salt Lake City in 1862. He opened the Leslie Hay Yard in a large stone building on the Emigrant Trail (now Pike Street). Leslie also ran a livery stable, where he rented horses and camels—a group of unusual pack animals. The US Army had brought the camels out west to haul supplies and salt across the desert to the Comstock mines. However, the rocky Nevada terrain cut their hooves, and the horses fled in terror when the camels were around, so the experiment did not last long. Leslie's stone building, known as the Camel Barn, is now an antiques shop. (CHD.)

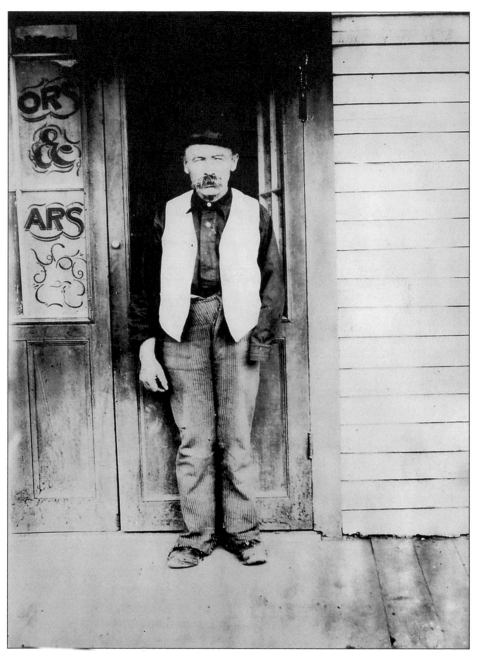

Otto Schroder poses at the front door of his Old Sazarac Saloon on Main Street sometime after December 1901. He is missing his left hand, the result of a fight with Dayton resident Bert Cassinelli. Stories about the incident were published in three newspapers after Otto had his finger and thumb chewed during the altercation. "It's now honeycombed with gangrene and he might have to have his arm cut off," reads the *San Francisco Chronicle*. The *Virginia Enterprise* notes: "He came to this city and on Friday, Dr. Pickard amputated the thumb. The trouble was caused after Cassinelli called on his wife, from whom he was divorced a short time ago, and who went to live in a house owned by Schroeder. The latter ordered Cassinelli from the premises and the fight ensued."

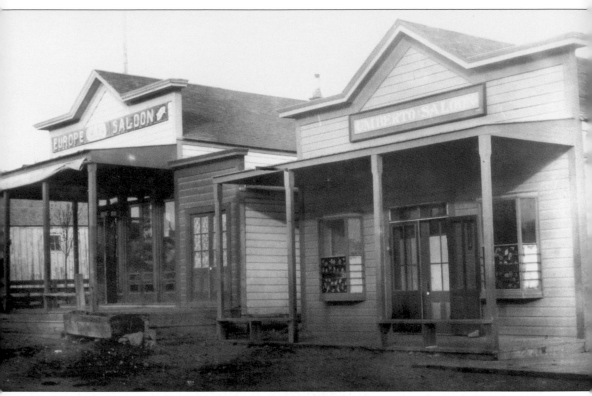

Since opening around 1905, the Europe and Umberto saloons, standing side by side on Main Street in Dayton, have teemed with life. The Europe Saloon (left) has usually been a bar and a residence since it opened. Michele Quilici and Amadeo Panelli owned the bar in the early 1900s, and it was later renamed the Europa (Giometti's Bar), then Bob Lee's and the End of the Trail, owned by Vita Hinman. It stood vacant for a few years until the Gold Canyon Steakhouse and Wild Horse Saloon opened in the 1990s. Over time, inside these doors, Italians, Indians, cowboys, ranchers, farmers, and hippies have danced, laughed, cried, tossed down a brew or two, and dodged a few fisticuffs. The Umberto, also called the American Bar, burned down in 1981 during the Quilici Mercantile Building fire. The Umberto Saloon's former site is now a parking lot. (Zenas Walmsley.)

Four

PIONEER TRANSPORTATION

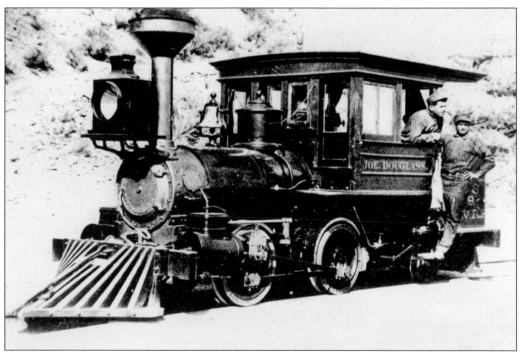

The *Joe Douglass*, the engine used on the Dayton, Sutro & Carson Valley Railroad line, arrived in Dayton in 1882. The little Porter engine pulled ore cars of tailings from old millsites to be reworked at the Birdsall-Douglass Mill on River Street. Fred Birdsall had owned the mill and built the first local rail system, pulled by horses, to move ore or tailings from Gold Canyon to his mill on River Street. Before he sold to Douglass, Birdsall had replaced the horses with two small engines he named *Fred* and *Ernie*, after his sons.

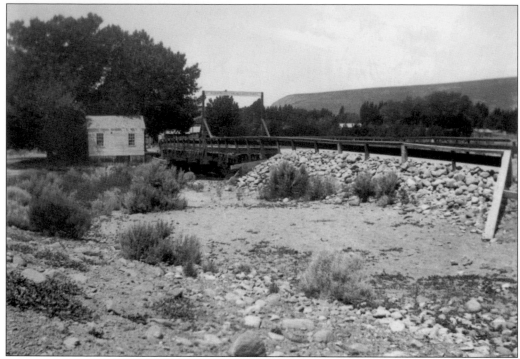

Built in 1862, Bolivar Roberts's tollhouse and bridge on the Carson River in Dayton was at the east end of Main Street, at the site of the old river crossing on the Emigrant Trail. This was the only bridge in the valley where thousands of pioneers traveling to California could safely cross the river. The bridge also served freight wagons hauling wood and charcoal from the nearby mountains. Prior to this business venture, Roberts was a supervisor for the Pony Express, which had a mail-delivery station in Dayton in 1861.

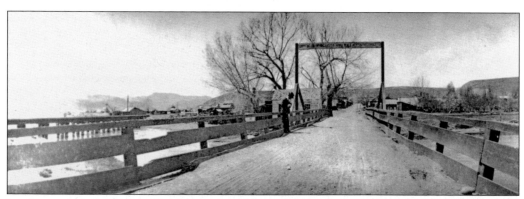

Looking west into Dayton, the view in this photograph shows the simple construction of Bolivar Roberts's one-lane bridge and wagon road, built in 1862. A section of the Carson & Colorado Railroad bridge, built in 1881, can be seen at far left.

These photographs show two of the eight Baldwin engines that kept the Carson & Colorado Railroad line running between Mound House and Keeler, California, beginning in 1881. Shown above is C&C engine No. 3, the *Colorado*, which was built in 1881. Below, C&C engine No. 6, the *Hawthorne*, was built in 1889. These engines were scrapped in 1907 or 1908. (Both, Dr. Linda L. Clements.)

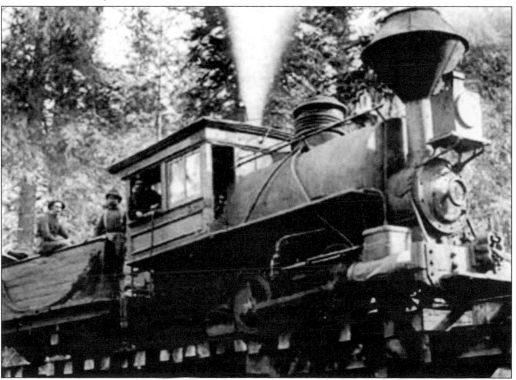

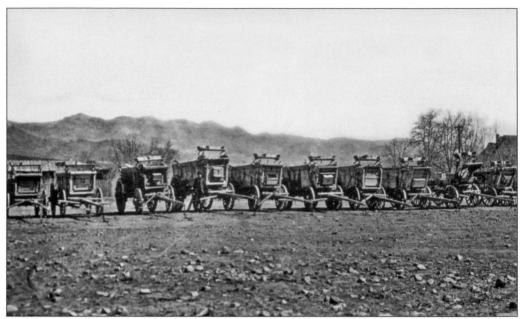

When Dayton's population reached its early-day peak of 2,500 in 1865, wagons and buggies were sold or rented at a number of livery stables and hay yards. In 1862, about six hay yards did business on Main and Pike Streets, including those of John Black, Hinds and Horton, George Hymer, George Leslie, and a Mr. Chubbuck. Another hay yard, going strong across the Carson River Bridge, served the Eldorado Canyon woodcutters.

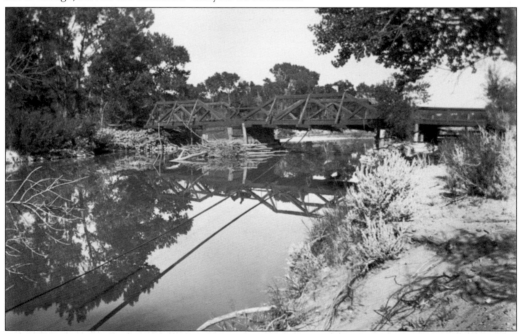

Adolph Sutro, the mastermind behind the engineering marvel known as the Sutro Tunnel, had this bridge erected over the Carson River around 1870. The bridge allowed him to travel directly from his home at Sutro to his two ranches on the south side of the river, where the Minor Ranch is today. A close look reveals a man riding a horse across the bridge.

This photograph shows the Six Mile Canyon toll road between Virginia City and Dayton. In the mid-1800s, this was Pierre and Edith Sicard's home. Houses, mills, gardens, and orchards created a scenic view along the wooded canyon's roadway. After the toll road closed and residents moved, the houses were either dismantled or moved to Virginia City. (Adele Englebrecht.)

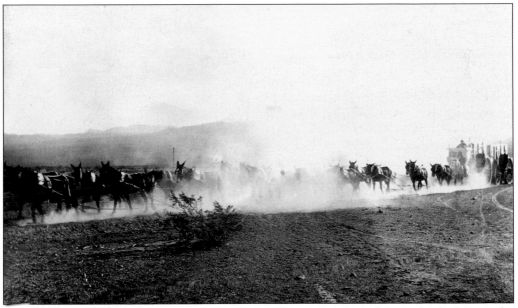

The teamster controlling the reins of this 20-up mule team is almost lost in the dust. From the 1860s through the 1880s, dozens of heavy wagons pounded the dry dirt roads daily around Dayton. To handle the heavily loaded wagons, teamsters had to possess skill, strength, and stamina. They were essential to Nevada's early mining and milling booms.

A man and a woman pose for a photograph next to a four-wheeled buggy in front of a home in Dayton Valley. In the 1800s, few folks could afford to buy a buggy, but they could rent one from a livery stable to take a Sunday ride.

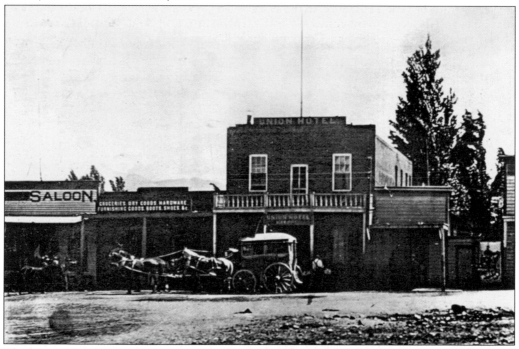

The Union Hotel on Main Street was a major Dayton stage stop for about 40 years. The Concord stagecoach seen parked in front of the Union belonged to George Barton, who carried mail and passengers to nearby towns on a daily schedule beginning around 1875. When it was time for the stagecoach to leave, Barton drove around town, ringing a bell, to remind residents that he was leaving soon. "He has faithfully carried his duties for 35 years, although he suffered a stroke that left him deaf," wrote Dayton historian Fanny Hazlett.

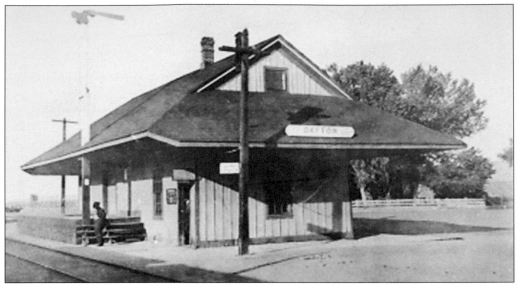

The 1881 Carson & Colorado Railroad depot is pictured in 1914 at its original site on Railroad Street, It was later reconfigured to be a Southern Pacific depot. Southern Pacific had purchased the railroad in 1900 and by 1904 had changed it from a narrow gauge to a standard gauge. However, after business waned, the Southern Pacific closed the depot in 1934. It stood empty for years, and then became a residence. In the 1950s, when US50 was realigned, Chester and Helen Barton moved the depot to the corner of US50 and Main Street, where it became their residence. Today, the depot is owned by Lyon County and the Historical Society of Dayton Valley oversees it. (Will Scott.)

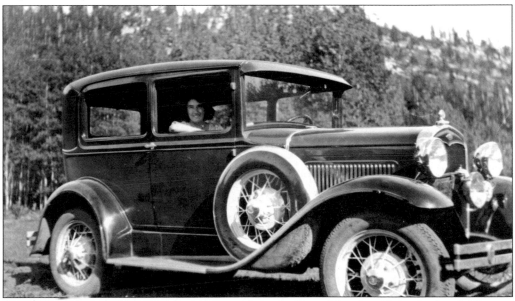

An adventurous lady, Helen Barton enjoys a ride in the Sierra Nevada with her husband, Chester, in their 1931 Ford. A native of Carlin, Nevada, Helen called Dayton home from 1931 until her death in 1996. Together, Helen and Chester operated a number of businesses, including the Old Corner Bar (now J's Bistro), rental properties, and a Shell gas station on US50 adjacent to their home.

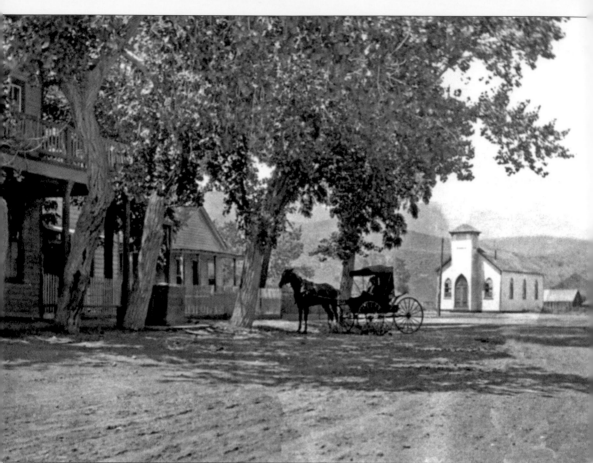

The horse and buggy was still in vogue in Dayton around 1905, when this photograph was taken. The Episcopal church in the background had been moved to Dayton from Gold Hill two years earlier. The home at Pike Street and Logan Alley was a "hurdy-gurdy" house, or dance hall. Today, it is Compadres Restaurant. The Lyon County Courthouse was right across the street.

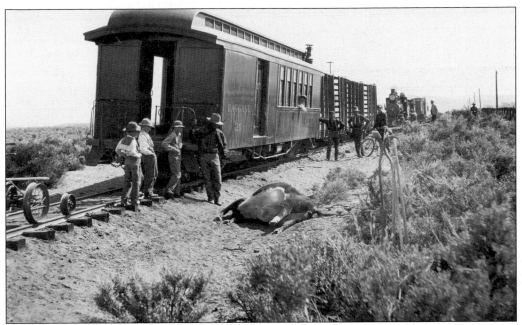

In the above photograph, three young cowboys, a rancher, and other spectators stare at a dead cow lying alongside the railroad tracks a few miles east of Dayton around 1900. Below, passengers watch the trainman fixing something between the cars. When cattle and the iron horse shared the open range, collisions were common. Engineers were trained to avoid hitting livestock and had to reimburse the rancher for a dead animal if the wreck was deemed preventable. Cowcatchers were mounted on engines to avoid incidents like this, but the cattle had minds of their own. (Both, Lawrence Lathrop.)

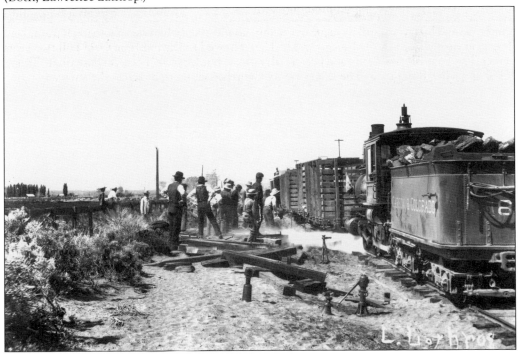

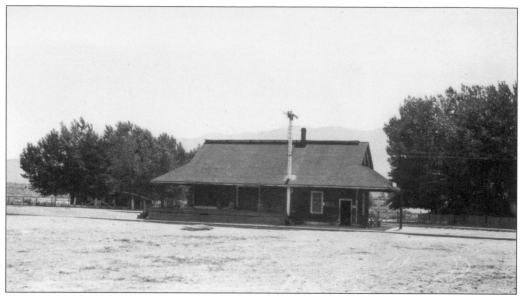

When this photograph was taken in the early 1900s, the Carson & Colorado Railroad depot in Dayton was painted dark red, with white trim, and it had a green shingled roof. The depot began doing business in May 1881 as the first station built specifically for the C&C line. The railroad stimulated Dayton's economy after the town had weathered three devastating fires, the end of the Comstock mining boom, and a national recession.

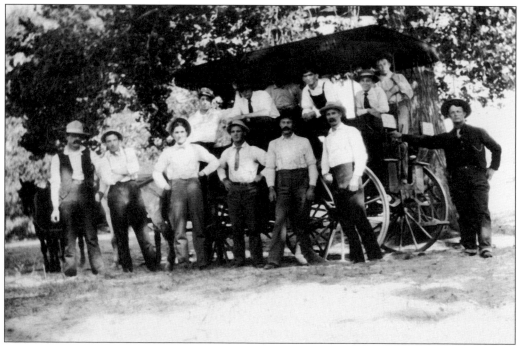

Russell Schooley stands to the right of the large stagecoach with which he was taking the Dayton men's baseball team to a nearby town for a game.

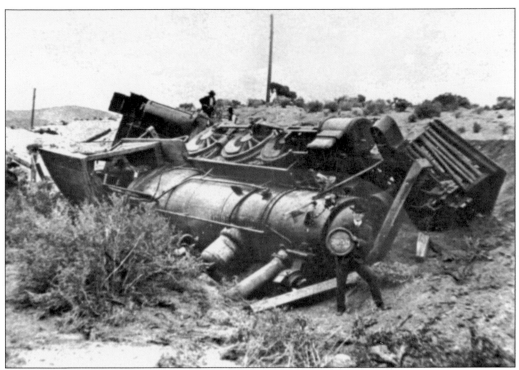

In May 1906, standard-gauge Southern Pacific locomotive No. 2158 jumped the track and rolled over an embankment near Mound House, west of Dayton. Engineer T.K. Allen escaped unharmed, but a fireman, a Mr. Bindley, was slightly injured. Allen told the *Reno Evening Gazette* that he was running at a low speed when the engine suddenly swerved and toppled over. A faulty roadbed may have caused the accident.

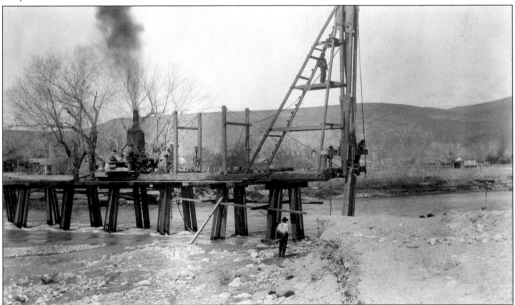

Southern Pacific railroad crews use a steam-operated steel pile driver to replace the Carson & Colorado Railroad bridge after the disastrous Carson River flood in March 1907 washed it away.

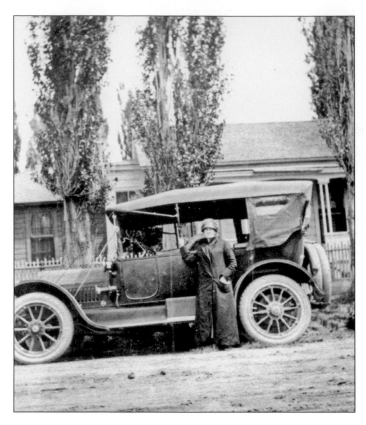

Emma Nevada Parker Barton Loftus poses next to her 1912 Ford Model T touring car. Loftus wrote a daily journal of life in Dayton, including the names of residents, from 1917 to 1958. The diaries are archived at the Dayton Museum. She moved to Dayton from Yerington in 1893 after the death of her husband, Thomas Barton. She later married Jack Loftus, a prominent Lyon County official, and they spent the rest of their lives in Dayton.

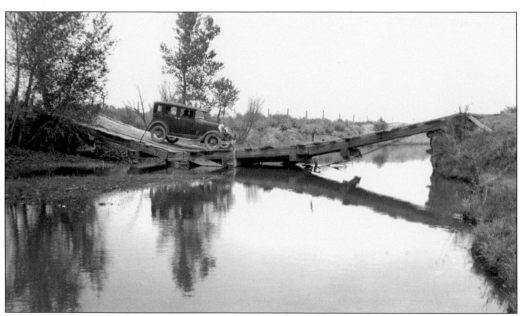

A 1930 Ford Tudor crosses the Carson River east of Dayton. Considering the crude, homemade bridge, this trip could have been a perilous and wet excursion.

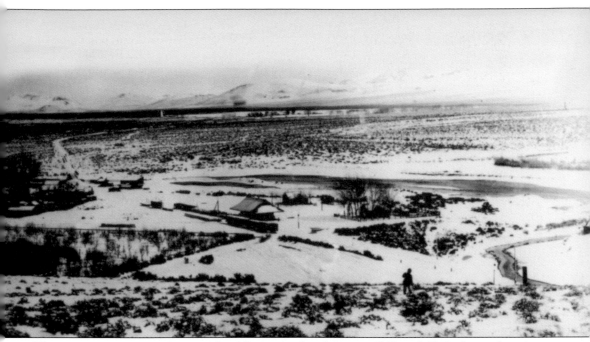

This panoramic winter photograph of Dayton, taken between 1888 and 1893, shows the route of the Carson & Colorado Railroad. At lower right, the train tracks enter Dayton from Mound House, cross the Carson River, and run northeasterly across the valley to reach the river again. The rail route followed the river to Fort Churchill and turned south to Wabuska on its way to Keeler, California, extending 300 miles in all. This view also shows how the river channels meandered through Dayton. In the immediate foreground, the C&C depot and the stationmaster's and section foreman's houses can be seen at their original locations on Railroad Street. The houses remain and are homes today, but the depot was moved a block north on US50 in 1955, when the highway through town was realigned.

When the piercing whistle of a steam engine announced the arrival of a train at the Carson & Colorado depot, the residents of Dayton turned out. "The townspeople gathered at the depot to watch what was going on . . . who came in and who went out," wrote Inez Shirley Macaulay, who grew up on Silver Street near the track in the late 1800s and early 1900s. "We five little kids lined up on the back fence and waved to the trainmen." Besides providing transportation for Dayton residents, the C&C was their lifeline to the outside world. The telegraph office was located at the depot, and the trains carried the mail and supplies for residents and businesses. When the railroad and the depot closed in 1934, townspeople felt as if they had lost a friend.

Five

FARMING AND RANCHING

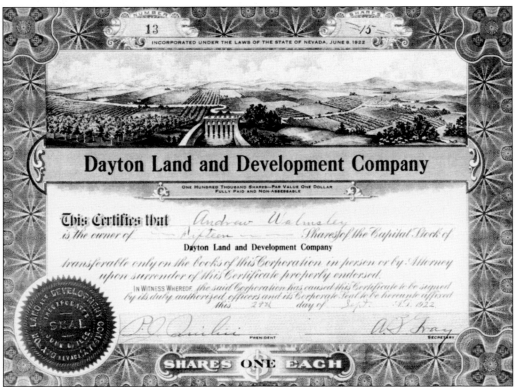

When this stock was purchased in 1922, the Comstock and local mining booms had ended, and old-timers' dreams for Dayton's future as an agricultural community abounded. It is unknown how much stock the investor sold to raise money for an elaborate dam on the Carson River, but it is obvious now that the vision failed. However, Dayton Valley was a significant farming and ranching community until the 1990s, when ranchland began to be replaced by houses.

Luigi Quilici (right) began his family's Dayton legacy in 1881, when he bought a ranch east of town. The Italian immigrant and three of his five sons—Victorio, Duilio, and Salvatore—ran the ranch until around 1916. Meanwhile, Luigi's wife, Margherita (below), would not leave Italy. She had heard stories from other Italian immigrants about the hardships of ranch life along the Carson River. Luigi returned to Italy permanently in the early 1900s, and his sons Smeraldo and Duilio ran the ranch. In 1946, after their deaths, the youngest son, Rugerro, inherited the ranch and brought his wife, Annunziata "Nunzia" and their three children—Salvatore, Rita, and Ledo—from Italy to Dayton in 1948. A fourth child, Larry, was born here. At first, schoolwork was a challenge for the kids. Rita recalls, "We couldn't speak English, so reading was hard, but we sure beat them when it came to math." Rita was named after her grandmother, Margherita, but she was christened Rita. In 1960, Rita and her husband, Domenic Selmi, bought the ranch, now known as the Quilici-Selmi Ranch. It is the oldest single-family-owned ranch on the lower Carson River. (Both, Quilici-Selmi.)

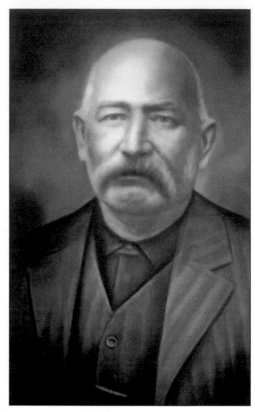

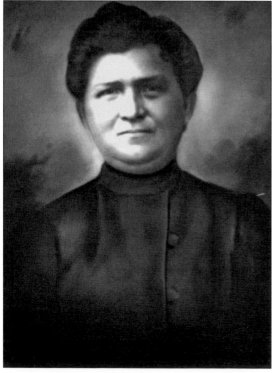

This outhouse stood on Pike Street at the Walmsley Dairy Farm in the late 1800s. Built with square nails, it served Zenas and Lela Stevenson Walmsley and their children—Thomas, Beatrice, Raymond, and Lois. In his later years, Zenas's children wanted him to move into Carson City so he could have modern conveniences. He replied, "I'd rather move into the hills near Como." He ended up staying in Dayton. (Laura Tennant.)

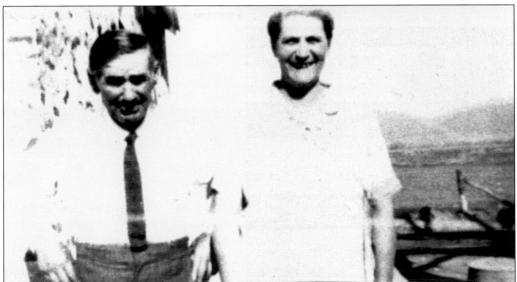

The Cardelli Ranch was developed when Italian immigrant Tancredi Cardelli, a miner and woodcutter, and his brother Orlando bought ranchland on the Carson River six miles east of Dayton in 1875. The brothers increased the size of the ranch to 1,200 acres, and their families made a living there for 50 years. Tancredi's first wife, Julia, died, leaving him with three daughters to raise. He later married Eugenia, a widow with two sons. Tancredi and Eugenia (pictured) were blessed with six more daughters. After the parents' deaths, family members ran the ranch until the 1950s. Later, the ranchland was divided after the settlement of a 12-year family dispute over property ownership.

Farmers and ranchers in the fertile Dayton Valley used water from the Carson River to irrigate their crops. The Randall Ranch's 1880s irrigation ditch began southwest of Dayton at a dam constructed on the south side of the river. Here, the cliff had blocked its path, so a wooden box flume connected the ends of the ditch, which carried water three miles to irrigate the alfalfa fields and gardens growing at the Randall Ranch, where the golf course is now located. (Adele Englebrecht.)

Astride a horse on the Heidenreich-Minor Ranch, located about five miles east of Dayton, Carolyn "Cam" Minor is holding her baby brother, Tom. Standing in front of the horse is her brother Steve. Little Julie stands with her mother and father, Del and Gene. A baby sister, Mary, came along a few years later. Around 1950, the Minors pioneered the Carson River's isolated southeast side, when they left Reno to live near the Heidenreich-Minor Ranch, where skunks and coyotes were their companions. They farmed and ranched, started Nevada's first pheasant preserve, were community volunteers, and Del was a founder of the Dayton Museum. Today, the Minor family still runs the cattle ranch. (Julie Minor Workman.)

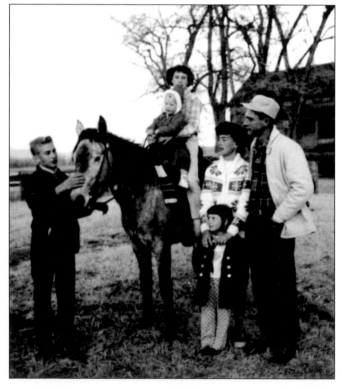

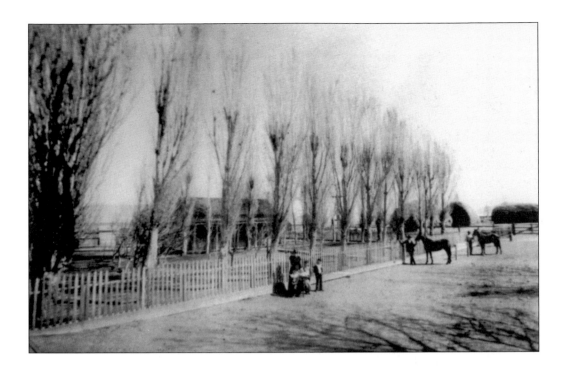

The Randall Ranch, owned by Dixie Perry Randall, was developed one and one-half miles southeast of Dayton around 1890. Old maps and the US Census indicate that the area had previously been called New Jerusalem and the Peacock Ranch. Situated at a site suited for farming, the 560-acre ranch became one of the more profitable agricultural sites in Dayton Valley, where Randall raised racehorses and crops, including alfalfa, wheat, barley, and potatoes. The ranch was so productive that the Carson & Colorado Railroad managers added a siding to the site. Today, an Arnold Palmer–designed golf course and subdivisions mark the spot. (Both, Dorothy Randall Layman.)

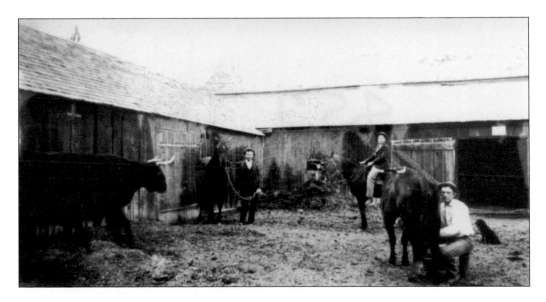

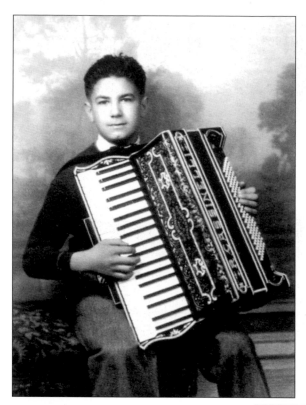

Between 1889 and 1910, Petro and Theresa Cassinelli raised 12 children on their ranch near Dayton. Their son Raymond preferred playing the accordion to tilling the soil. He studied music in San Francisco and excelled as an accordion player. Raymond and his friends formed the Raymond Cassinelli Dance Band, and in the 1930s and 1940s, they played for hire in Nevada and California, including at the Odeon Hall in Dayton. After Raymond's death, his son Dennis donated the accordion to the Dayton Museum on Shady Lane. In a 1906 Dayton Grammar School photograph, there are eight Cassinelli students. (Dennis Cassinelli.)

Eugene Howard was a Dayton rancher in the early 1860s. Said to be a friendly fellow, Howard was described by Zenas Walmsley as "a big man, weighing around 260 pounds, who was a cowboy and rancher a good many years. Later, he sold his ranch and cattle and bought a home in town, where he raised a fine family, three girls and one boy, and owned the Union Butcher Shop." When the Howard children reached college age, he and his wife, Eloise, sold their home and business and moved to Berkeley, California, to give their children a college education. They all earned degrees.

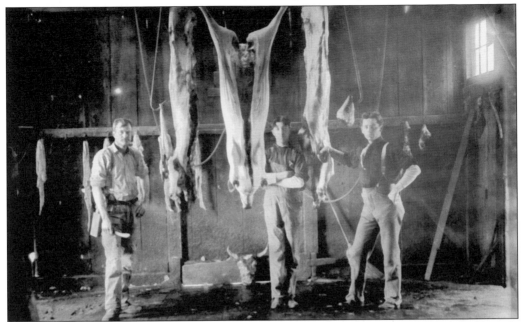

Eugene Baglin (left), Thomas Conway (center), and Will Gruber stand inside Eugene Howard's slaughterhouse, posing with the porkers they have prepared for Howard to sell at his butcher shop. At the turn of the century, residents depended on area ranchers to produce the meat for a families, boardinghouses, and restaurants.

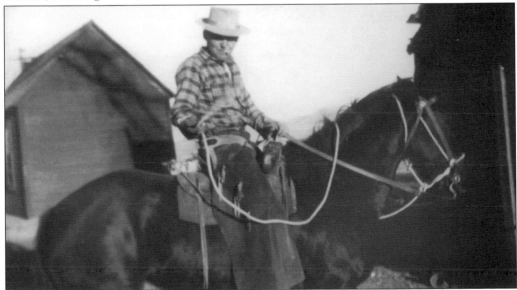

The son of an Italian rancher, Domenic Selmi was delivered by a midwife in June 1921 in a house where St. Ann's Catholic Church is now located. His father, Angelo, and mother, Iole, emigrated from Italy in the early 1900s and bought a ranch near Fort Churchill. Iole was not happy living in the desert, so the family returned to Italy. At age 16, Domenic returned to Dayton, where the Army drafted him to serve in World War II. After the war, he worked on the Baroni and Quilici Ranches and married Rita Quilici in 1959. Their children—sons Gary, Danny, and Randy—are now engineers. (Quilici-Selmi.)

This stone oven, used primarily for baking large round loaves, was located on the Ophir ranch southeast of Dayton. During the 1900s, most Italian ranches in the valley used old-fashioned stone ovens, reminiscent of those used back in Italy. Enough bread was baked at one time to last the family a week, and it was stacked and stored in wooden barrels, where it stayed fresh. At the beginning of the 20th century, 27 out of 28 ranches on the Carson River between Dayton and Weeks belonged to Italians.

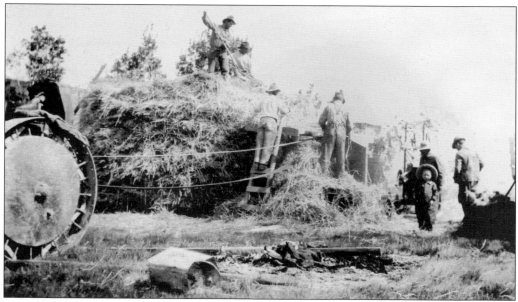

Putting up hay in the early 1900s on a hot summer day was a dirty, sweaty job for Dayton ranchers. The boy on the right seems more enthralled with the cameraman than with the hay-handling team of workmen. These ranchers are preparing loose-stacked cut hay for winter storage.

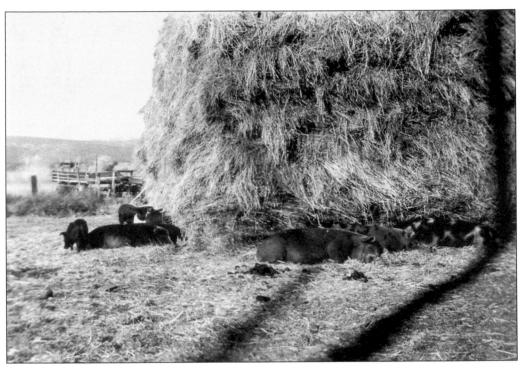

At the Ricci Ranch, several sows and their piglets discover that stacked, loose hay makes a nice spot to snooze. This ranch, where truck farming began around 1900, is one of the few working ranches in town today. (Grace Ricci.)

Bert Perondi (left) and Ray Walmsley enjoyed getting together and trading stories about the good old days at Perondi's small farm in Dayton, where the 76 gas station is today on US50. The Dayton natives were lifelong friends. Perondi was born in 1920 near the Sutro Tunnel site, two miles north of Dayton. He spent much of his childhood at his grandparents' Cardelli Ranch east of Dayton. His buddy Walmsley was born in 1925 on the Walmsley family's dairy farm on Pike Street. Walmsley passed away in February 2014. Perondi lives in Dayton. (Laura Tennant.)

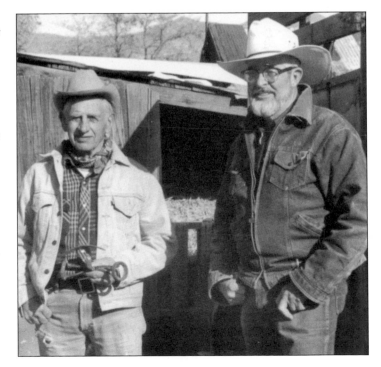

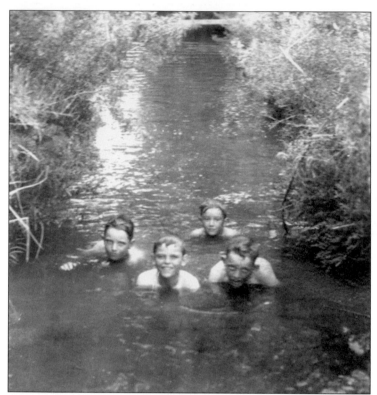

Joe Ricci (left) and his friends enjoy a refreshing dip in the ditch that carried water from an upstream dam on the Carson River to the Rock Point Mill, north of town. In the 1920s, swimming in the Rock Point race was a favorite pastime for kids growing up in Dayton. Joe was born on the Baroni Ranch, which his father, Bernardo, later purchased. Today, the Ricci Ranch is one of the oldest working ranches in Dayton. (Grace Ricci.)

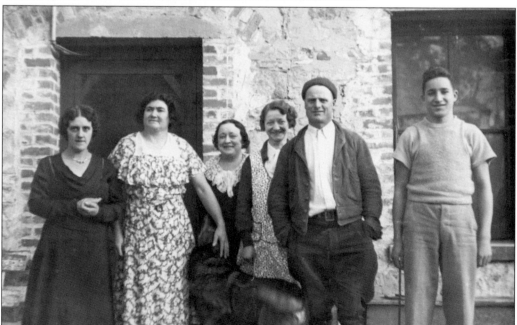

Members of the Bernardo and Eliza Baroni Ricci family stand at the entrance of their Dayton home in the early 1900s. Eliza is second from left, and her son, Olinto, is on the far right. Eliza emigrated from Italy to Dayton in 1913 with her husband, Bernardo. They had two sons, Joseph "Joe" and Olinto. Joe's wife, Grace Ricci, 87, lives in this house today. (Grace Ricci.)

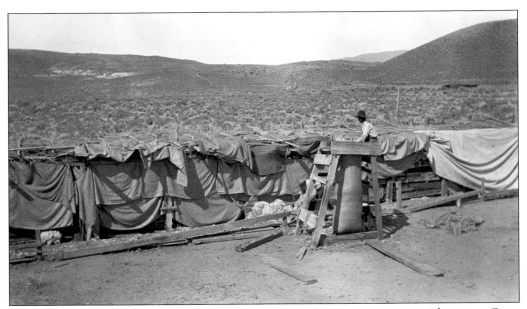

A band of sheep stands in line inside a makeshift covered pen to receive spring shearings. Once the sheepshearers clipped the raw wool, other workers would pack it in woolsacks to prepare it for marketing. Camille Pradere, a Basque immigrant's son, said, "The Urratias had a big sheep camp in the Pine Nut Mountains, and thousands of head of sheep grazed around Dayton during the winter months in the early 1900s." Camille's son, Michael, still raises sheep on the Pradere Ranch, across US50 from Our Park.

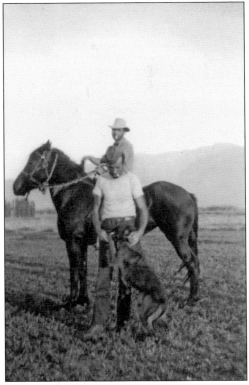

Albert Sbragia stands with his dog Pinto and his friend Domenic Selmi (on horseback) around 1948. Sbragia and Selmi were partners on the Baroni Ranch, about a mile northeast of Dayton. They raised potatoes, vegetables, melons, and other row crops, which they sold to customers in Virginia City, Gold Hill, and Silver City. A portion of the ranch today is the site of the Holley Family Farm. In the mid-1950s, Sbragia and his wife, Alda, built the Dayton Inn and operated it until his death in 1996. The Dayton Inn remains a local favorite today. Their adult children—Alberta, Nancy, and Joe—manage the Sbragias' holdings today. (Nancy Sbragia.)

No one calls this house on the Minor Ranch home anymore. The place has survived many floods since Adolph Sutro bought the Gee and Moore hay ranches, east of Dayton on the Carson River, in the early 1870s. Sutro, constructing the Sutro Tunnel across the river, wanted three miles of river frontage on which to build stamp mills. Other known owners of the ranch include Roy Heidenreich, Henry and Minnie Heidenreich, and George and Addy Minor in the late 1940s and the 1950s. Today, the Minor family works the large ranch. (Julie Minor Workman.)

Six

FLOODS, FIRES, AND PEACEKEEPERS

A hose cart, used to supply water from a cistern, and a Hunneman hand pumper stand outside the Dayton firehouse, next to Gold Canyon Creek, around 1900. After the fires of 1866 and 1870 leveled the downtown business district, Charles Gruber, the Union Hotel's owner, donated $100 to begin a fundraiser to modernize the volunteer fire department beyond the era of bucket brigades. Wooden, wire-wrapped pipe and cisterns were installed around town. Man-drawn firefighting equipment was used until 1936, when a motorized engine was purchased.

This 1935 Ford LaFrance fire engine was the first new motorized vehicle owned by the Dayton Volunteer Fire Department. The department's pride and joy, the fire engine was delivered in 1936 and remained in service until the 1970s. Known as "Granny" today, the classic red fire truck occasionally comes out of retirement for special events. (Ray Walmsley.)

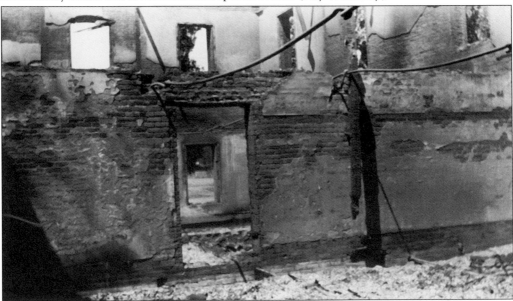

Charred brick, mortared walls, and a foundation were all that remained of the Lyon County Courthouse after a fire gutted it in 1909. These remnants were incorporated into the exterior construction of Dayton's first high school, which opened on the same site on Pike Street in 1918. The building is today the Dayton Valley Community Center. (Will Scott.)

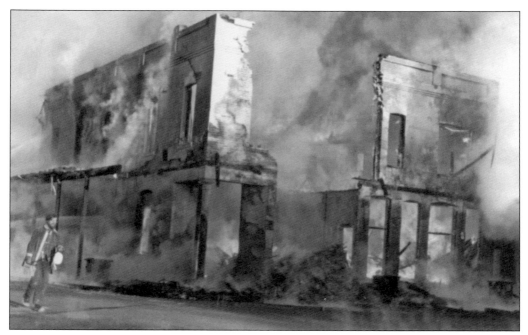

In April 1981, a disastrous fire struck downtown Dayton. By the time local firefighters arrived on the scene, the Quilici Mercantile Building was completely engulfed by fire. Explosions sent flames shooting into the air like rockets. The volunteers doused the blaze before the town's entire historic section burned, although a residence and two adjacent businesses could not be saved. The new owners were later found guilty of arson. Before the Quilici building was constructed at the corner of Pike and Main Streets, fires at that site had destroyed the two-story Roberts House in 1866 and its replacement, the three-story United States Hotel, in 1870. (Both, Dayton Volunteer Fire Department.)

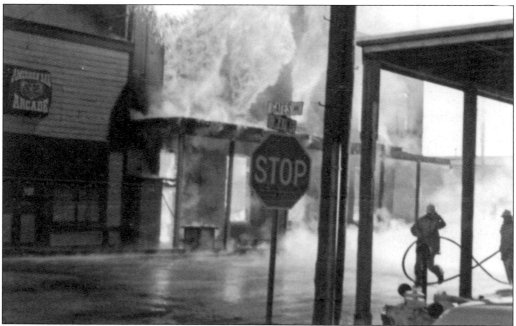

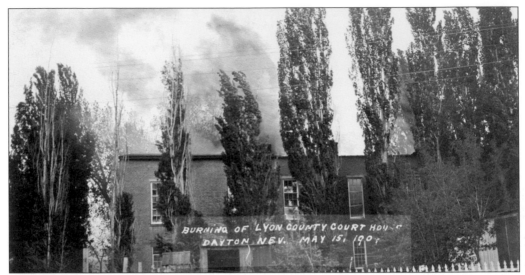

During a trial at the Lyon County Courthouse on Pike Street on May 15, 1909, a fire erupted in the attic. Worn insulation on the outdoor electrical wiring had looped around a tree, caught in the building's wall, and sparked the blaze. While the fire raged, officials did what they could to save county records. Recorder and auditor Clark Guild's office was on the first floor, and the courtroom and treasurer's offices were on the second floor. Guild reported, "I stood by the vault and passed out every document and book from my office to the jurors who carried them across the street, but all of the records upstairs were lost." When Guild and friend "Gamble" Lotche were leaving, Guild said, "the big safe dropped through the ceiling from the treasurer's office. That's how close we came to staying." The county set up offices in the Quilici building, and court was held at the Odeon Hall for several years. Meanwhile, the towns of Mason and Yerington were vying for the county seat. In 1911, Nevada legislators voted to move the county seat from Dayton to Yerington. (Both, Will Scott.)

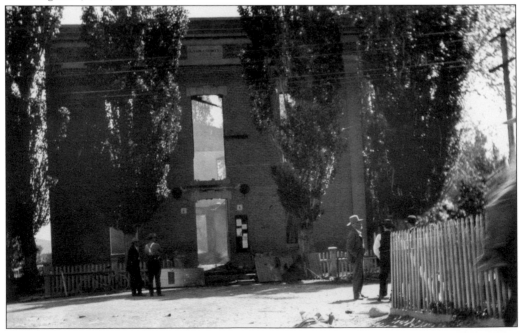

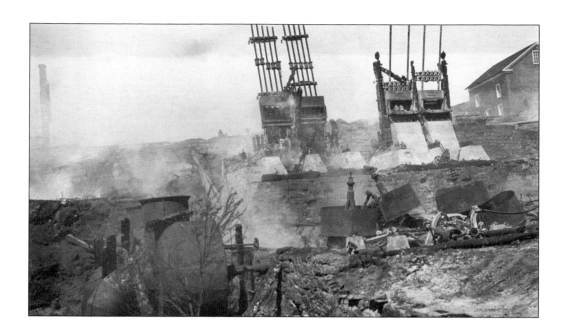

In May 1909, the Nevada Reduction Works & Power Company mill went up in flames. Mill owner Capt. Herman Davis said it was arson. He told the *Carson City Daily* that "giant powder was used and heavy mill timbers were blown in every direction by the explosion." He also noted that there was "not a stick of powder, can of oil nor a flask of quicksilver" in the mill that could have sparked the fire. Before this catastrophe, Davis had spent $80,000 to repair a dam washed out by the 1907 flood, and it was ready to reopen. The newspaper's editor recommended that Dayton citizens "rise up and run the hombre that fired the mill out of the country." The charge of arson was never proven. (Both, Will Scott.)

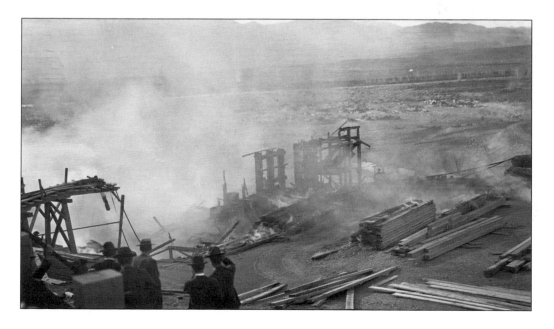

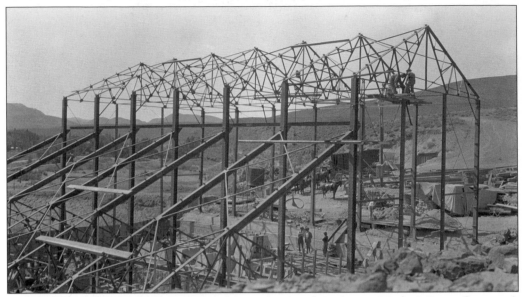

After the May 1909 suspected arson burned down the Nevada Reduction Works & Power Company's stamp mill at the old Rock Point Mill site, the owner, Herman Davis, had it rebuilt. However, when the mill was running again in 1910, he sold it and moved his family to Reno. Davis had operated a prosperous milling and mining operation in Dayton since around 1890. (Will Scott.)

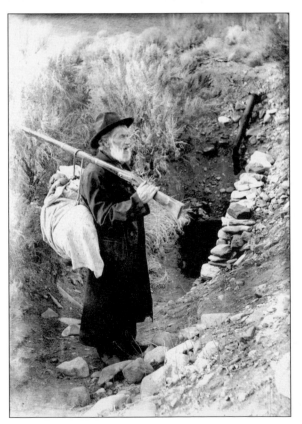

Charlie Norris, the Dayton justice of the peace in 1901–1902, lived in a dugout on the outskirts of town. "He preferred this way of life. Notice the chimney and the handrail going into the cave," noted Eloise Howard, a Dayton resident then. A Civil War veteran, Norris had also served with the Third Kentucky Infantry in the Mexican-American War.

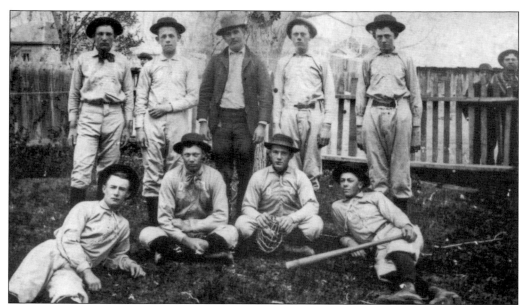

In 1864, members of Dayton's town baseball team gathered for a photograph. They are, from left to right, (first row) Lew Shaw, Harry Randall, Clarence Tailleur, and Eugene Campbell; (second row) Ellis Randall, Henry Jaqua, George Shaw, Fred Tailleur, and Harry Riley. George Shaw, the team's manager, was the Lyon County sheriff. (NHS.)

Between 1882 and 1936, three generations of the Randall family dominated Lyon County sheriff's politics. Pictured are, from left to right, (first row) Dick P. and his father, George Perry Randall; (second row) George's grandson Dick Clark "Dixie" and Arthur Randall. D.P. ran for office on the "Democracy" ticket. George and his wife, Mary, settled in Dayton in 1874. (NHS.)

Dorothy Randall Layman was born on the Randall Ranch, where the Dayton golf course is today. After her mother's death from appendicitis, Dorothy was sent to a private Catholic school in California, but Dayton was dear to her until her death in 1993. Her vast collection of Dayton historical items includes a picture from her scrapbook, pictured below. The top three photographs are of her brother Dick Clark "Dixie" Randall at different ages. He became Lyon County sheriff in the late 1920s after his father, Sheriff Dick Perry Randall, passed away. Dixie, known as D.P. Randall, was sheriff for 26 years. Highly regarded, he was known as one of the quiet, quick-acting peace officers of his time.

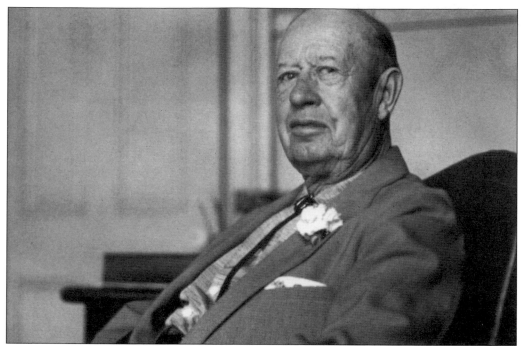

Judge Clark Guild had humble beginnings and today is remembered as a man who served Lyon County and Nevada. Born in Dayton in 1887, the youngest of 12 children, Guild worked the mines and railroads at age 16. When he lost a leg in a railroading accident, it changed his life. He earned a law degree and became the Lyon County district attorney. Considered a fair, competent prosecutor, he became a district court judge in 1925, serving for three decades. Guild is recognized today as the founder of the Nevada State Museum. (NSM.)

Known for driving unusual vehicles, Chester Barton, Lyon County deputy sheriff for 37 years, poses in what appears to be a Ford Model T pickup. He had a soft spot for children, animals, and the downtrodden, but no patience with criminals. Friends say Barton was handy with a sap, which he used, asking questions later. He once caught two men trying to rob the Old Corner Bar on Main Street. While one culprit sat in a getaway car, the other was breaking into the building. Chester shot the windshield out of the car with a shotgun and apprehended the thieves. He kept the peace in the western end of the county from 1929 to 1966.

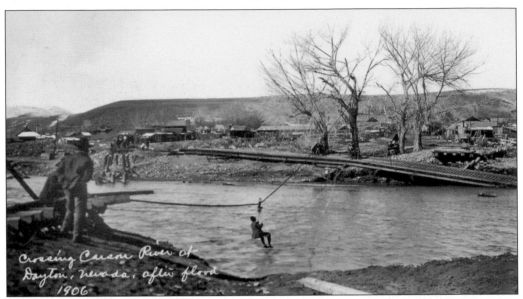

The Carson River flood of March 1907 washed out the town's wagon and railroad bridges, leaving ranchers and others marooned on the east side of the river. The chair shown here, attached to a steel cable connected to the other side of the river, was called a "go-devil." It transported people and supplies across the river. The date "1906" on this photograph is inaccurate. (Will Scott.)

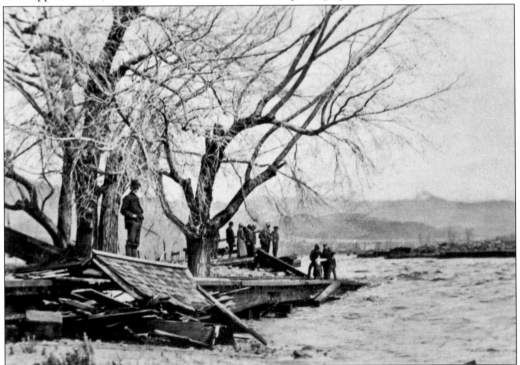

Surveying the scene after the March 1907 Carson River floodwaters subsided, the Dayton townspeople were stunned to see chunks of huge stamp mills, which had been washed downstream, lodged on local river banks, where the town's railroad and vehicle/pedestrian bridges had been located. The flood damage left many people unemployed.

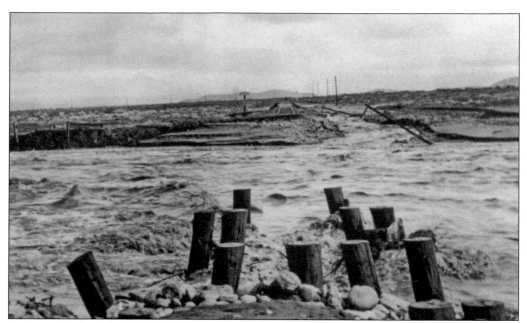

Little was left of the Carson & Colorado Railroad bridge after the flood of 1907 tore off its trestles. In this view looking east, on the other side of the Carson River toward today's Dayton Valley Road, the railroad tracks remain intact. The power poles previously standing next to the vehicular roadway have been washed out. Unlike today, in the 1800s and early 1900s, the river channel's banks were almost level with the adjacent land.

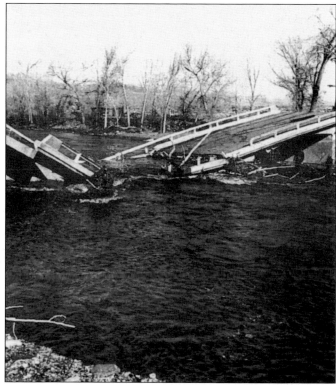

When the Carson River went on the rampage during the Christmas flood of 1955, the water eroded the banks on both sides of the Dayton Bridge, and it took a dive. When 14 inches of rain fell in the mountains for four days straight, the floodwaters crept in on Christmas Eve and waterlogged four ranch homes. At the pheasant preserve on the Minor Ranch, 1,500 birds perished. (Nevada Department of Transportation.)

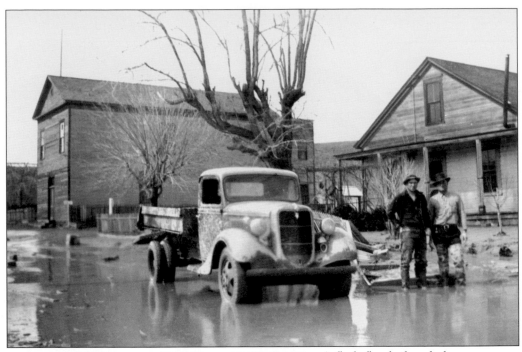

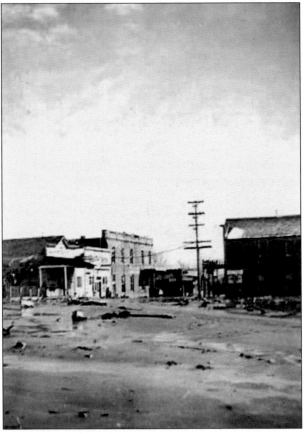

A flash flood of mud, slime, water, and debris rushed down Gold Canyon Creek into Old Town Dayton around one o'clock in the morning on March 12, 1938, as seen at left. Heavy rainfall had ruptured the old placer tailings dams in the canyon between Dayton and Silver City. Above, Eugene Howard (right) and an unidentified friend stand next to a 1935 Ford dump truck, in front of Howard's house on Main Street. The Druid Hall, the dominant structure in the background, appears unscathed. Damages reached $8,000, and five homes were filled with muck up to 18 inches deep. (Both, Leah Giometti O'Callaghan.)

Seven

BLENDING CULTURES

Captain Truckee, a Paiute chief, is remembered on a monument at US50 and Silver Street in Dayton. Truckee befriended white settlers and was a guide for John C. Frémont and other explorers. At times, Truckee lived in Dayton, as did Sarah Winnemucca, his granddaughter. Truckee died in 1860 and was buried near Palmyra, a mining camp in the mountains south of Dayton.

Indian tribes had lived around the Dayton Valley for thousands of years before white settlers arrived in the mid-1800s. Excellent shots, the Paiutes hunted with bows and arrows then. Before long, though, the Indians and white folks cohabited the valley, and by the early 1900s, Indians were hunting with rifles. After rabbits were skinned and cleaned, their skins were sewn together to make warm winter robes.

This photograph of an Indian village across the Carson River from Dayton includes a rare glimpse of Paiute leader Capt. Jim Davis. It also documents the cultural transition of Nevada's native people around 1900. While living in a traditional dwelling, the Indian residents had moved closer to town and built shelters from the white settlers' materials. (Etta C. Swart.)

Known as a peacemaker, northern Nevada Paiute chief Numaga was responsible for a treaty between area Indians and the US Army at Fort Churchill in 1861. A year later, when woodcutters began chopping down hundreds of trees in the pinyon forests south of Dayton, the Paiutes protested. Pine nuts from the pinyon trees were a primary food source for the Indians. Numaga negotiated a deal with the woodsmen, who paid the Paiutes $400 in compensation. (NHS.)

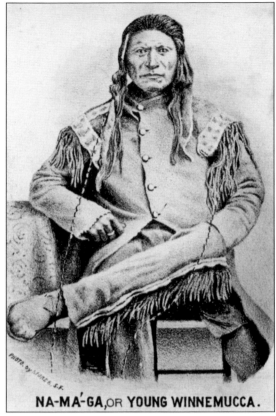

NA-MA'-GA, OR YOUNG WINNEMUCCA.

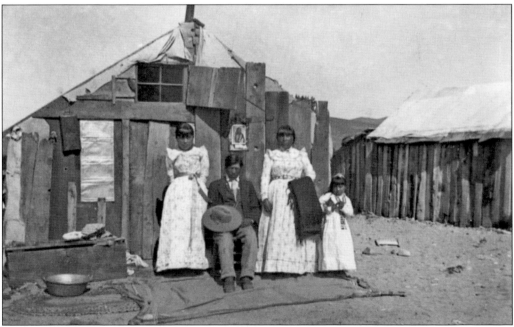

Paiute Indians pose outside their canvas-roofed homes in the early 1900s. Most local Indians lived across the Carson River east of town.

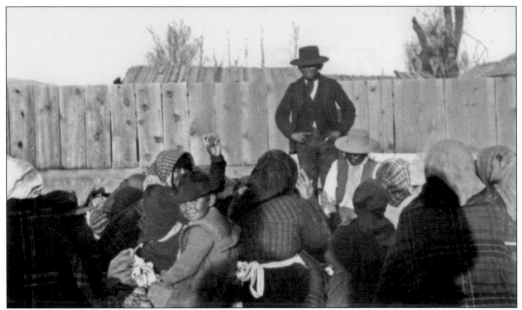

Gambling was popular with Native Americans, who engaged in games of chance at gatherings and celebrations. These members of the Paiute tribe are wrapped in wool blankets on a chilly day in Dayton. The woman on the left is holding up three playing cards to show her winning hand.

A baby laced inside a traditional Paiute buckskin cradleboard and a girl in a cotton dress document the period when the local Indian culture was in transition to more modern styles around 1900. Washoe and Paiute tribes lived in and around the Dayton Valley for thousands of years.

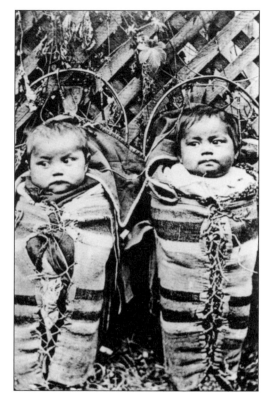

Cuddled in their cradleboards, these two Paiute babies at right appear apprehensive as they wonder what the photographer in front them is doing. Below, when the camera clicks and flashes, the little ones loudly pronounce their feelings.

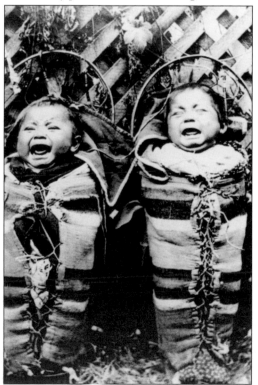

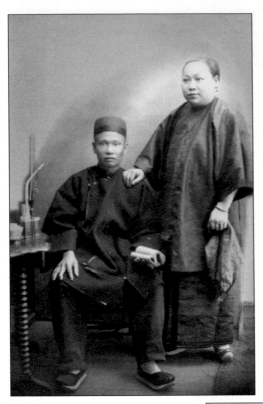

Chinese immigrants Hep Sing and Ty Kim, early Dayton residents, were married in San Francisco in 1874. He was 22 and she was 17. Ty Kim was born in Canton, and Hep Sing was a native of Fat Shan, Canton Province (modern Guangdong). Dayton native Zenas Walmsley, a friend of the local Chinese residents, preserved their photograph and marriage license, which are on display in the Chinese section of the Dayton Museum.

This unidentified girl lived in Dayton's Chinatown in the mid-1900s. She is dressed in traditional Chinese attire. Her silk outfit highlights her best black slippers and the backdrop of the embroidered quilt adds a cultural touch. A frame house still remains in old Chinatown at Railroad and Silver Streets, next to the Sinclair gas station. (Ray Walmsley.)

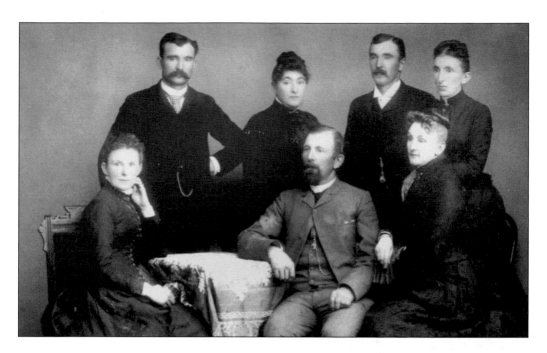

Of Joanna and Herman Shirley's twelve children, seven have etched their names in Dayton's archives. Pictured are, from left to right, (first row) Mary, William, and Etta; (second row) Franklin, Victoria, Herman, and Louise. William, the eldest son, immigrated to Dayton first and settled here in 1860. He was the superintendent at the Rock Point Mill and represented Lyon County in the Nevada Assembly in 1887. Franklin and his wife, Hattie, married in Dayton and raised five children on Silver Street, where his orchard flourished. Herman died at the Sutro Tunnel in a construction accident While on a hunting trip, Will Scott (left) and a friend are camped in the Pine Nut Mountains, south of town. Their log cabin is built of pinyon logs. Note the coyote pelts hanging on the cabin walls and the cast-iron Dutch oven hanging over a small fire.

An outdoorsman, Dayton resident Chester Barton kept a number of rattlesnakes at home, along with his collection of wild pets. He constructed pens and had a zoo in his backyard at the corner of Main Street and US50. His wife, Helen, said she did not mind the bear, the coyotes, the monkey, or the 90-pound bobcat, Chico, who lived in the house with them. But she would have nothing to do with his rattlesnakes. At times, Chester had 50 rattlers in a candy showcase cage and would run his hands through the twisted pile of snakes. He was bitten a number of times with no ill effects. Chester's story is in the 1991 edition of Lyon County Reflections.

Eight

SCHOOLS, FRATERNITIES, AND CEMETERIES

The Dayton Grammar School, the oldest schoolhouse in Nevada standing at its original location, celebrates its sesquicentennial on August 1, 2015. In the autumn of 1865, the clang of the school bell first echoed around town to announce the opening of the new one-room school. Before the schoolhouse was built, students were taught at a private residence. In 1873, a second classroom was added, where high school courses were also taught between 1911 and 1918, the year Dayton High School opened on Pike Street. After the school closed in 1959, the building served as a community center, senior center, and Sunday school. In 1994, it became the Dayton Museum, operated by the Historical Society of Dayton Valley. (Ray Walmsley.)

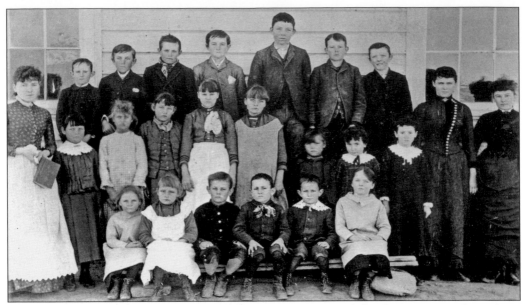

This professional cabinet card photograph of Dayton Grammar School's primary-grade students reflects the styles of children's clothing in 1882. The photographer was with the William Cann Jr. studio on C Street in Virginia City.

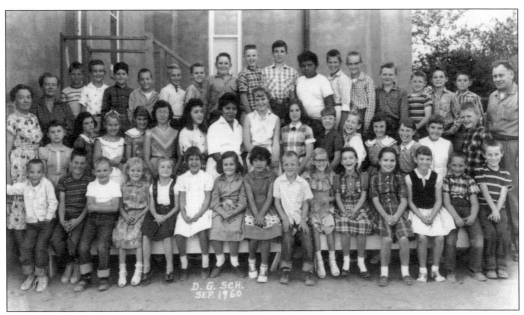

This class portrait of Dayton's elementary school students was taken in 1960. When Dayton's grammar school and high school closed in 1959, the grammar school students were moved to the high school building on Pike Street. They attended school there until 1971, when the new elementary school opened on Dayton Valley Road. On the far left is teacher Violet Bennetts. Standing behind her is teacher Bernice Johnson. On the far right is Raymond Bean, the school principal.

Eloise Howard, born in Dayton in 1903, learned to read from this primer in the early 1900s while attending Dayton Grammar School. Printed on oilcloth, the primer was published in 1877 in Philadelphia by J.B. Lippincott & Company. Eloise's daughter Adele Englebrecht donated the primer to the Dayton Museum on Shady Lane.

Members of the old Dayton High School's 1925–1926 girls' basketball team demonstrate skills taught by their coach, a Miss Thein. The team competed with western Nevada schools such as Fernley, Sparks, Reno, and Virginia City. Closing the season in Dayton, the girls defeated Virginia City 32-24, reports the 1926 *Desert Canary* yearbook: "We feel proud of our season. Owing to the fact there were not enough students in school to have an entire high school team, we called on the Junior High to fill in." That year, 17 students attended school on Pike Street, including seventh through twelfth grades, with three teachers at the helm. Shown here are, from left to right, (top row) Marie Cardelli, coach Julia Thein, and Anita Cardelli; (middle row) Iva Mary Inda, Georgina Quilici, and Ida Gruber; (bottom row) Lena Cardelli, Sadie Zannini, and Lula Kendall. (Lula Kendall.)

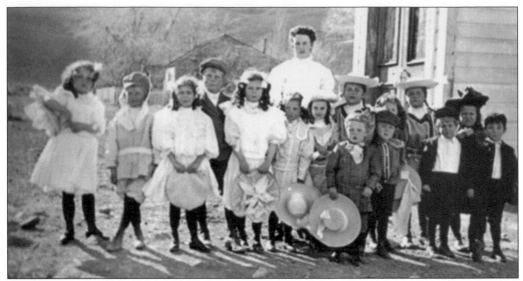

In the early 1900s, these fancily dressed Dayton youngsters, including girls with their Easter bonnets, appear to be posing at a Sunday school taught by Rose Harris at the Episcopal church on Pike Street. The church had been moved from Gold Hill in 1903. (Herman Davis.)

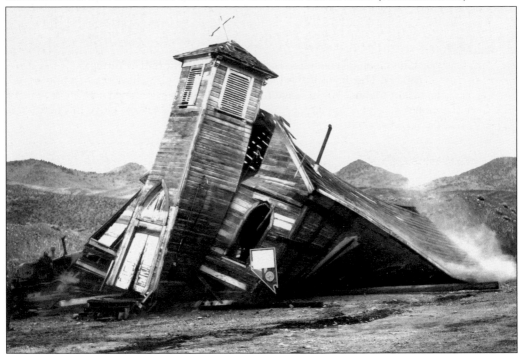

In 1974, *Gold Hill News* reporter and Dayton resident Jim Crandall snapped this action shot of the historic Episcopal church in Dayton as it was being bulldozed by Lyon County. The privately owned building was on county property. Officials decided it was unsafe and ordered the church demolished without notifying its owner, Albert Sbragia. In the center, a Nevada Historical Marker denotes the church's significance in the state's history. The community was raising funds to restore the church, which had been a saloon in Gold Hill before being moved to Dayton in 1903. The steeple and a tall gothic-arch window frame are on display at the Dayton Museum.

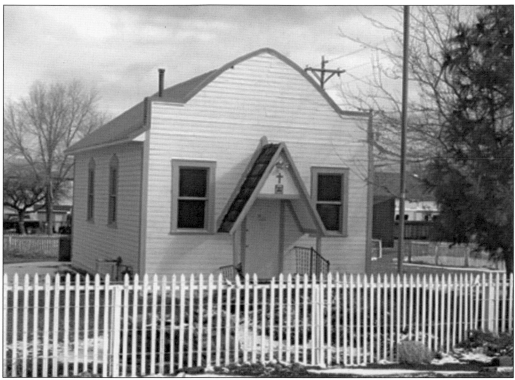

St. Ann's Catholic Church on Pike Street in Dayton was a Catholic hall in Yerington before it was moved to Dayton in 1937. The townspeople had to contribute funds to have the building moved. Having a church meant so much to the Dayton Catholics that they donated a dollar or two at a time until the money was raised. A larger St. Ann's Church, at 3 Melanie Drive in Dayton, has replaced the Pike Street church.

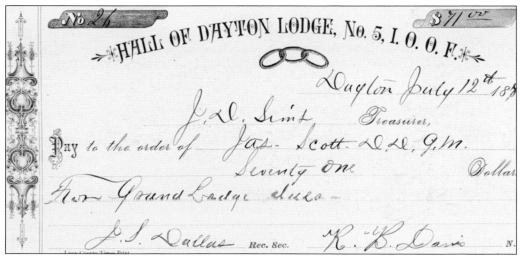

The two-story Odd Fellows Hall of Dayton Lodge No. 5 was constructed on Pike Street in 1863, when the Independent Order of Odd Fellows organized in Dayton. It was the first fraternal society to formally organize here. The lodge hall and offices were located on the second floor, with store spaces rented on the first floor. It later became the Odeon Hall and Saloon.

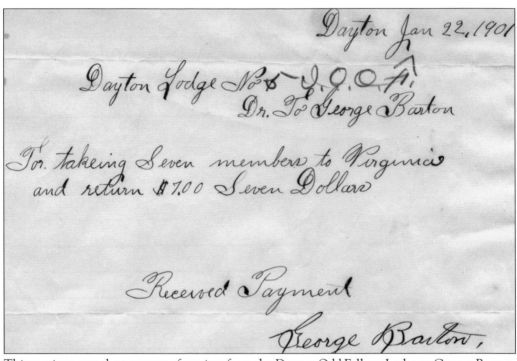

This receipt notes the payment of services from the Dayton Odd Fellows Lodge to George Barton, proprietor of a stagecoach line that ran daily between Dayton and Virginia City for 35 years.

This 1959 photograph of the Dayton Haymakers basketball team and cheerleaders still conjures bittersweet memories for older DHS graduates, because it was the last year the Haymakers would play. These players did their all and went down fighting, upsetting Gerlach at the Western Nevada B-zone tournament and qualifying for the Nevada state playoffs. DHS teams had competed against area schools since the school opened in 1918. The cheerleaders are, from left to right, DeLinda Kraai, Gail Nieri, and Sheila Donovan. The players are, from left to right, Mike Pradere, Harry Bennetts, Ledo Quilici, Mike Kinkel, Bill Kinkel, Russell Pradere, Terry Cassingham, George Armstrong, Franklin Frank, and coach Raymond Bean.

Friends for most of their lives, these Dayton folks are gathered at the Dayton Senior Center, the old Dayton Grammar School, for the 100th birthday party of their former teacher, Bertha Scott. In front are Bertha Scott (left) and Georgina Quilici Ballom; behind Scott's nephew, Gordon Pearl, and Camille Pradere and his wife, Victoria. Scott began teaching in this room in the 1900s and taught in Dayton for three decades. With television cameras rolling, Scott was pulling the rope to ring the school bell when a lightweight piece of ceiling panel fell on her head. Everyone held his breath. She smiled, shook her head to remove the dust, and carried on, to cheers and loud applause. She lived to celebrate her 103rd birthday. (Laura Tennant.)

The United Ancient Order of Druids, Dayton Grove No. 8, was organized in 1927 by Italian residents, who met in the Druid Hall. The original booklet that lists the names of the group's founders and members is written in Italian. Ruggero Quilici was the *conduttore*, or chairman. Town dances, funerals, vaudeville shows, Catholic mass, and other events were held here. The building was dismantled in the late 1950s.

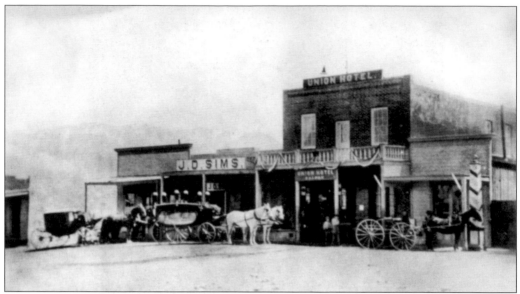

In March 1886, at the Union Hotel on Main Street, townspeople gathered to mourn the death of Charlie Gruber, owner of the hotel. An elegant hearse and two horses stand ready to carry his remains to the Dayton Cemetery west of town. His funeral was held at the Lyon County Courthouse on Pike Street. Gruber and his wife, Caroline, had the hotel built in 1870.

This Dayton High School photograph was taken in 1931. Principal John Argusa is seated in the second row with teachers Lois Carman (third from left) and Bernice Johnson (third from right). Johnson began teaching at Dayton High School in 1928. Through the years, she served as a teacher, principal, and boys' basketball coach, and she held the small school together until June 1955, when she retired as a teacher.

This gravestone in the upper section of the Dayton Cemetery marks the burial site of Edward P. Lovejoy in August 1891. He was the only child of Celia and Elijah Lovejoy. Elijah, an abolitionist and newspaperman, was killed by a proslavery mob in Illinois in 1837, and he became known as the first American martyr to the freedom of the press and the slave. By 1880, Edward and his wife, Julia, lived in Wabuska, a town 25 miles southeast of Dayton, where he was the stationmaster for the Carson & Colorado Railroad and owned the Wabuska Inn. The Historical Society of Dayton Valley hosted a ceremony in 1993 at the Dayton Cemetery, during which the father and son were recognized by US senator Paul Simon, who wrote a biography of Elijah, *Lovejoy the Martyr*.

In 1939, for the second year in a row, the Dayton High School basketball team won the Nevada western conference championship for B division schools. The Haymakers were coached by former University of Nevada star Joe Radetich. From the 1920s through the 1950s, basketball competitions were a very important aspect of high school life, and fans packed Dayton's small gym for games. The 1939 champs are, from left to right, (first row) Al Parlanti and Albert "Bud" Longwill; (second row) Gilbert Martini, Bill Harris, Olinto Ricci, Victor Peri, and Bert Perondi; (third row) manager Dean Quilici, Ted Franklin, Bill Weir, Elio Martini, and Coach Radetich. When Dayton beat Virginia City 39-22 in the first game of the 1939 tournament, the *Nevada State Journal* reported that "Dayton displayed one of the most potent offenses seen in the tournament." The Haymakers nickname had a double meaning: Dayton had become an agricultural town and a haymaker is a "power punch."

Nine

AMERICANA

Vittorio and Assunta Della Santa and their daughter, Victoria, are dressed for a photograph at the Riverside Studio in Reno around 1923. Vittorio had emigrated from Italy 15 years earlier to come to America. A farmer, he ended up raising potatoes at Sutro. Vittorio saved his money and sent to Italy for Assunta. The Della Santas later farmed where S&S Market is today. Vittorio built a two-story barn and raised and sold fruits, berries, and vegetables. Near their house on River Street, he built a little store, where he sold fresh produce. It flourished, so he added canned goods, Italian pasta, and lunch meats. In the 1950s, Victoria ran a Chevron gas station on the family's property on the Lincoln Highway in Dayton. She pumped fuel herself, often surprising customers when she appeared, late at night, wearing high heels and a fancy dress. Victoria raised two daughters, DeLinda Kinkle and Duana Lompa, and a son, Victor Kirby. (DeLinda Kinkle.)

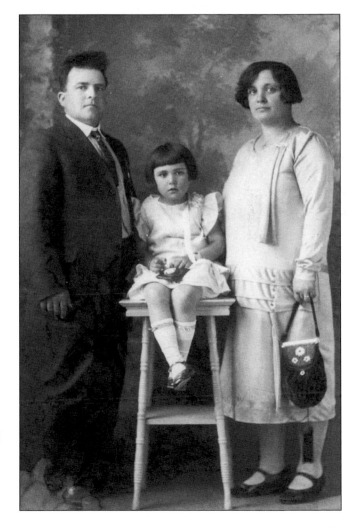

Emma and John Lothrop's home, located near the mouth of Gold Canyon, reflects the style of most houses built in Dayton in the late 1800s. Emma and their son Richmond stand in front of the house. Emma, a Pennsylvania native, and John, born in Missouri, married in Dayton in 1864 and had four children, who stayed in town. John served as a Lyon County deputy sheriff, county clerk, and recorder.

"Clum" Cooper was born in Dayton in 1893. He was the 11th of 12 children and the only son born to Silas and Lauretta Cooper, who settled here around 1883. When Clum was 14 years old, he struck out on his own when his father gave him $2 and told him to "get out." He worked in the mills and mines and did odd jobs, including hauling sand and gravel in a horse and cart during the construction of the Quilici Mercantile bar and hotel around 1906. Later, Clum married and had three sons—Mel, Earl, and Wyneth—who still live in the Carson City and Reno areas. (Mel Cooper.)

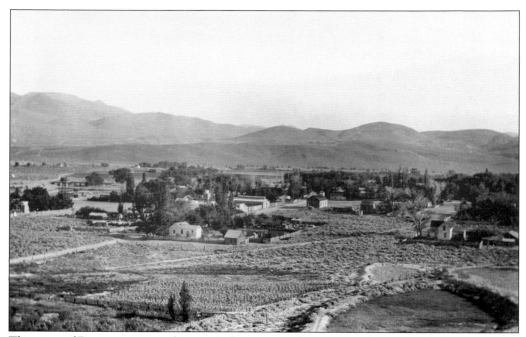

This view of Dayton captures the town's character in the summer of 1908. On the left, a farmer's corn patch flourishes, and to the right, settling ponds indicate that mining is still a way of life. Shady Lane can be seen on the right, and Pike Street is on the left. (Will Scott.)

Leah Giometti, about age eight, poses in the orchard in her family's backyard. Their living quarters were attached to the backside of the Europa Bar on Main Street. The large barroom was heated with a cast-iron stove that took three-foot logs. The only room heated in the house during the winter was the barroom, where Leah did her homework. When the temperature dropped below freezing, she recalls hearing the "pop" of the soda bottles when they cracked. The Giometti family owned the bar from 1921 to 1962. (Leah Giometti O'Callaghan.)

Young ladies and gentlemen of Dayton socialize at a fall picnic held near the Carson River around 1920. Shown are, from left to right, a Dr. Dempsey, Eva Dandurand, Hazel Gerry, Clark Guild, Lena Dandurand, Lillie Lothrop, and Harold Gignoux. Picnics were common outings, including for high school students, in the town's early days.

Breakfast is served at Tom's Place in Dayton on May 29, 1922. Tom, the cook, stands in the kitchen doorway. The photographer identified the customers as, from left to right, Clarenback, Shorty, McCrank, an unidentified man, ? Tremble, Blackie, and Old Mack. (Mel Cooper.)

The photograph shows the houses of a few early settlers whose homes on upper Main Street were moved to make way for the gold-dredging operation of the late 1930s. From left to right, the houses belonged to Auntie Eston, the Box family, the Swarts, William Schooley, T.P. Mack, the old trading post cabin, and—on the far right in the trees, on Shady Avenue, now Shady Lane—Fanny and Dr. J.C. Hazlett. (Lawrence Lothrop.)

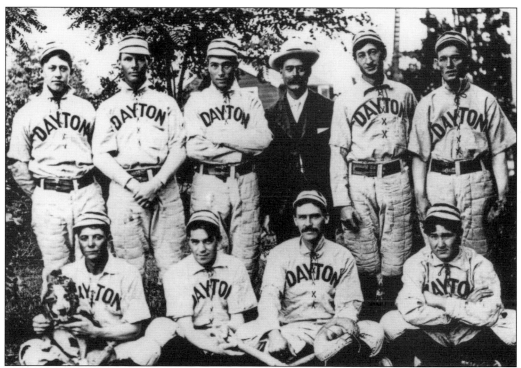

It was an honor to play on a Dayton town baseball team in the late 1880s and early 1900s. These players look as if they are tough competitors. Shown are, from left to right, (first row) Guy Hungate, Angelo Scananino, Frank Kornmayer, and Bert Baroni; (second row) Clark Guild, Earl Chase, Zenas Walmsley, manager Manuel King, Will Scott, and Fred Johnson.

This 1901 invitation announcing a gathering of the Dayton Social Club is cleverly designed on a brown paper bag. The original is on display at the 1865 schoolhouse, now the Dayton Museum on Shady Lane.

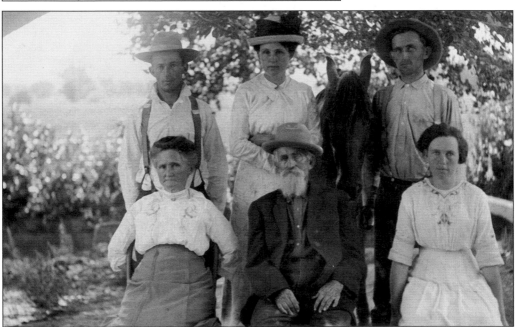

The Perkinses, a Dayton pioneer family, pose for a portrait. According to the US Census, Nancy Perkins lived in Dayton with her husband, Albert, and their three sons and two daughters in 1910. Shown here are, from left to right, (first row) Nancy, Ralph, and Josephine Perkins; (second row) Daniel Perkins, Effie Collier, Jack the horse, and Gus Perkins. Nancy was born in 1861 in Illinois and is buried at the Dayton Cemetery.

In the late 1930s, the Europa Saloon's proprietor, Giorgia Giometti (right), and her daughter Leah pose for a photographer passing through town. A family friend, August Bucchianeri, stands at the end of the bar. Giorgia's uncle Amadeo Panelli owned the bar when she immigrated to Dayton from Italy in 1914 to be a maid at the boardinghouse. A year later, Giorgia eloped with Elia Giometti, her uncle's bartender. The couple rented two rooms from Eliza Wilson in a house that was attached to the Odeon Hall. In this house, Leah and her brother Louie were born. In 1921, Elia and Giorgia bought the Europa Bar. Elia died in 1929; Giorgia kept the bar running to support the family through the Depression and managed the business until her death in 1961. The Europa is today a restaurant. (Leah Giometti O'Callaghan.)

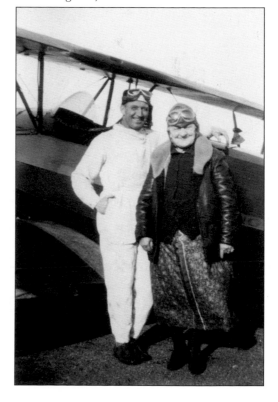

Lauretta Cooper, 76, of Dayton, had crossed the United States once by wagon and five times by train before she boarded this airplane in San Francisco in 1930. Given the choice of riding in a plane built for comfort, or one for speed, the mother of 12 quipped: "I want to go in a fast plane, and I don't want anybody but the pilot with me. I don't need a chaperone at my age." The pilot was Tommy Thompson (left). Afterward, Cooper said, "I never liked anything better." (Mel Cooper.)

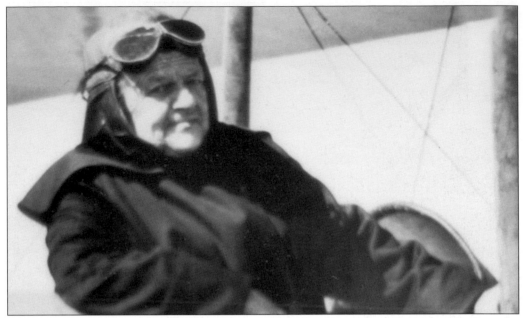

Spunky Fanny Hazlett made national news in 1922 when she took an "aeroplane" ride at the age of 84. "She flies in the plane over the city where she came in an ox-cart," reads a newspaper article. Hazlett, who arrived in Dayton in 1862, had met Brigham Young, heard Mark Twain lecture, socialized with Nevada's first governors and legislators, and written a history of Dayton. Around town, though, she was admired as Gramma Hazlett. She died at age 95 and was laid to rest at the Dayton Cemetery in the family plot.

Dayton in 1898 presents a peaceful scene, in this view looking south on Pike Street. The boisterous milling era had ended, and Dayton, the Lyon County seat, had become the political center of the county.

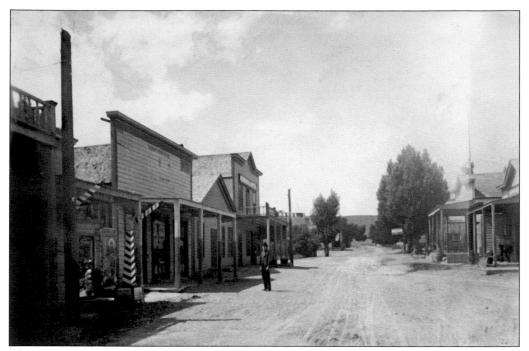

This 1890s photograph is a reminder that today's Main Street is located on the Emigrant Trail of the mid-1800s. The Union Hotel, on the left side of the street, and the quarried-stone buildings on the left have withstood the test of time.

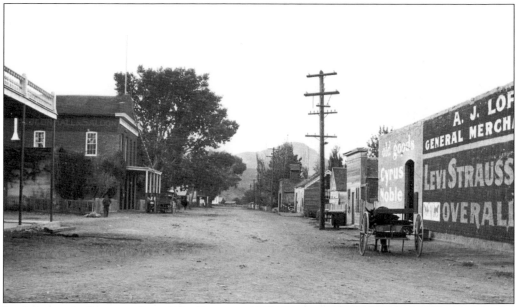

In this view looking north on Pike Street in 1909, Dayton is fairly deserted. In the 1850s, this roadway was one of the main pioneer trails to California and Nevada. The Odeon Hall (left), built in 1861, was damaged by fire twice, but it was never destroyed. It is possibly one of the oldest buildings in Nevada. (Will Scott.)

Dayton friends pose in front of Imelli's Meat Market on Main Street in the 1930s. Shown are, from left to right, (first row) Mrs. Leet, Eloise Howard, Sybil Barton, and Wilma Hankammer; (second row) Adelaide Howard, Eugene Howard, Emma Loftus, Charles Braun, and Steve Imelli. Eugene owned the Union Butcher Shop at this site for many years. The 1870s stone building houses a dog-grooming business today. (Adele Englebrecht.)

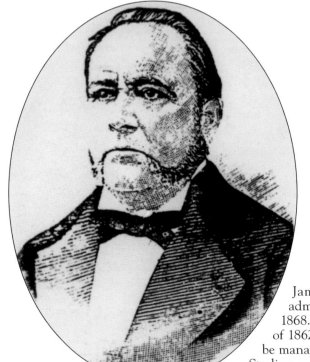

James H. Jaqua, Lyon County public administrator, was elected in November 1868. "One of the more ambitious projects of 1862, the formation of a gas company to be managed by Jaqua, Judge Haydon and M.W. Starling, never materialized. Kerosene and candles continued to light the burg," said Fanny Hazlett.

These Dayton dandies of the early 1900s are dressed in high fashion to have their portrait taken by a professional photographer. Note the low-cut shoes and white stockings. (Mel Cooper.)

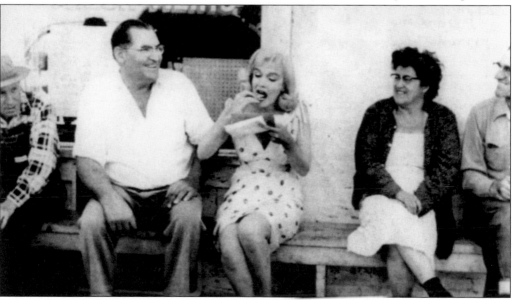

Eating a homemade taco, Marilyn Monroe (center) joins Dayton residents for lunch outside the Union Hotel and Dayton Post Office during the filming of *The Misfits* in August 1961. Savoring the moment, are, from left to right, Elio Martini, Lloyd Rupp, and Edna MacDiarmid, town postmaster. Marilyn's husband, Arthur Miller, is on the far right. Monroe, Clark Gable, Montgomery Clift, Thelma Ritter, Eli Wallach, and other cast members spent around two months in Dayton during filming. They commuted daily from the Mapes Hotel in Reno. Dayton residents recall that Monroe loved the town's children. She arrived in a pink Cadillac every morning, and was always late. (Toni Westbrook.)

During the filming of *The Misfits* in Dayton in the summer of 1961, the MGM crew built a rodeo arena at the northwest corner of Logan Alley and Pike Street for a scene. In the mid-1960s, the American Legion, local businesses, and ranches sponsored the Misfits Rodeo here. The arena was dismantled in the late 1960s.

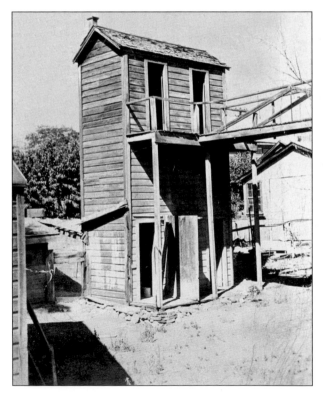

The two-story outhouse built in the early 1870s behind the Union Hotel was the only one of its kind in western Nevada then, and it brought Dayton notoriety. Hotel guests could reach the facilities either of two ways, by using a walkway from the upper story, or via a lower entry from a bedroom downstairs. The two floors of the outhouse had separate chutes. The outhouse disappeared sometime in the late 1940s. During interviews about Dayton, Helen Barton, Chester's wife, and his friends verified the story that he had the outhouse loaded on a semitruck, tied with a huge red ribbon, and shipped to his friend Dick Conklin's home in Hollywood. Chester and Dick, a wealthy insurance broker who owned the Break-A-Heart Ranch east of Dayton, often played practical jokes on one another.

Ten

A New Era

Dayton residents gather for a photograph in front of the Dayton Valley Community Center in 2012 to protest the possible closure of the center. The former Dayton High School building, owned by Lyon County, had been used as a community center since the early 1970s, but the county commissioners said they could not afford to operate it anymore. After a few meetings, the county agreed to lease the building to the all-volunteer Dayton Preservation Committee. The community center now remains open to citizens. (Jack Folmar.)

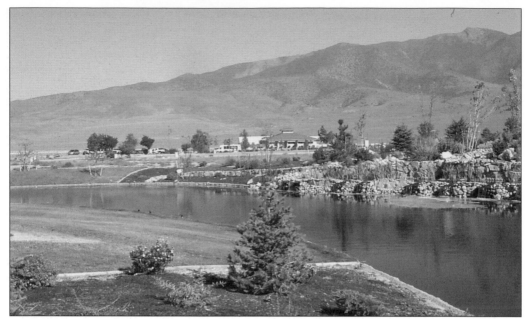

The construction of the Dayton Valley Golf Course created a unique change in the valley. The Arnold Palmer–designed course opened in 1991 and has been named one of the best golf courses in northern California, Reno, and Lake Tahoe. The 44 lakes integrated within the course, and the mountains surrounding Dayton Valley, create a pleasant place for people to live and play. (Jack Folmar.)

Dayton celebrated the sesquicentennial of Nevada's first gold discovery at the mouth of Gold Canyon in July 1999. After Gov. Kenny Guinn led a grand parade, the emcee, Don Dallas (pictured), welcomed the governor. At left are committee members Barbara Peck, Laura Tennant, and, behind her, Bonnie Matton. On the immediate right are Nevada's first lady Dema Guinn and her husband, Governor Guinn.

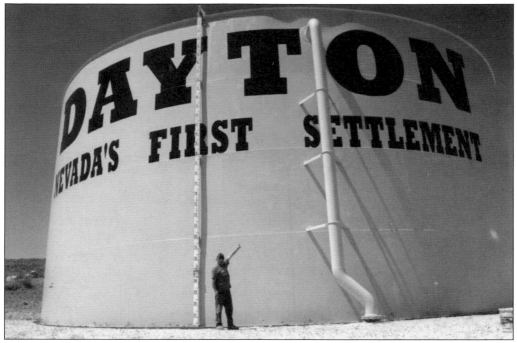

In May 2001, Dayton held a Founder's Day gala for the town's 150th birthday to commemorate its history as the first permanent Euro-American settlement in Nevada. Standing next to the Dayton water tank near the cemetery is Armand Arnett. The longtime Dayton volunteer coordinated the painting project.

The new Dayton High School, the home of the Dust Devils, opened in 1982 off of Dayton Valley Road. It educated students from the seventh to the twelfth grades from Dayton, Silver City, Mound House, Stagecoach, and Silver Springs. The first Dayton High School was built on Pike Street in 1918 and closed in 1959. In the intervening years, students were bused to Carson High School. (Jack Folmar.)

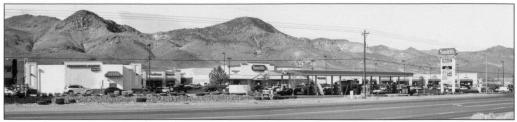

Smith's Food & Drugs, Dayton's first supermarket, opened on US50 in the spring of 1999. Dayton residents could not have been happier, because they did not have to drive to Carson City to shop for groceries or buy prescriptions. Since then, an extensive shopping center has developed that includes a gas station, fast-food establishments, restaurants, retail, and convenience stores. (Jack Folmar.)

May and Ray Walmsley were parade grand marshals when Dayton celebrated its sesquicentennial in 1999, marking Nevada's first gold discovery, which took place in Gold Canyon. Ray was the grandson of Dayton's 1860s pioneers Georgetta and Andrew Walmsley and Nancy and Thomas R. Hawkins. May's parents, Gladys and Vernon Cadwallader, settled in Dayton in 1937. High school sweethearts, May and Ray married in 1947 and raised their children, Geri and Gene. They were active in the town's volunteer fire department, 4-H, and historical society. (May Walmsley.)

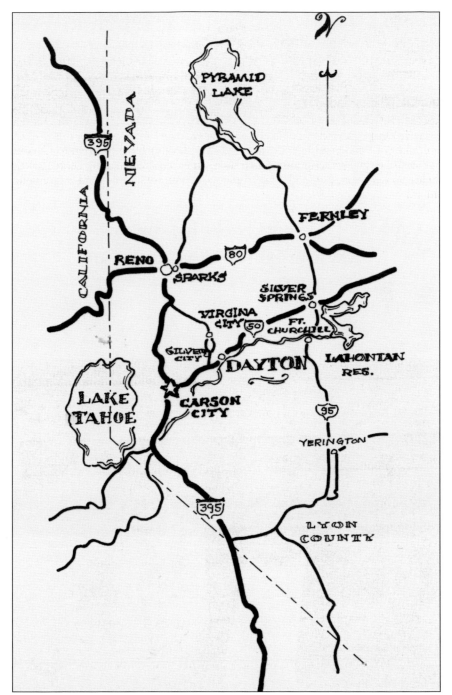

This map shows that Old Town Dayton is located in the heart of beautiful northwestern Nevada. The Historical Society of Dayton Valley invites visitors to step back in time, pick up a walking tour brochure at the museum, and stroll the same routes that prospectors, pioneers, and Pony Express riders followed 162 years ago; and to have lunch or dinner in Old Town, visit a casino, play golf at the Arnold Palmer Dayton Valley Golf Club, and enjoy the hometown hospitality that makes scenic Dayton Valley a unique place to visit.

DISCOVER THOUSANDS OF LOCAL HISTORY BOOKS
FEATURING MILLIONS OF VINTAGE IMAGES

Arcadia Publishing, the leading local history publisher in the United States, is committed to making history accessible and meaningful through publishing books that celebrate and preserve the heritage of America's people and places.

Find more books like this at
www.arcadiapublishing.com

Search for your hometown history, your old
stomping grounds, and even your favorite sports team.

Consistent with our mission to preserve history on a local level, this book was printed in South Carolina on American-made paper and manufactured entirely in the United States. Products carrying the accredited Forest Stewardship Council (FSC) label are printed on 100 percent FSC-certified paper.

MADE IN THE